John Sunderland

CONSTABLE

Phaidon

Phaidon Press Limited, 5 Cromwell Place, London SW7

*Published in the United States by Phaidon Publishers, Inc
and distributed by Praeger Publishers, Inc
111 Fourth Avenue, New York, N.Y. 10003*

This edition first published 1971

© 1970 by Phaidon Press Limited

*ISBN 0 7148 1473 3
Library of Congress Catalog Card Number : 75-141036*

*Printed in Great Britain
Text printed by R. & R. Clark Limited, Edinburgh
Plates printed by Ben Johnson & Company Limited, York*

CONSTABLE WAS A PAINTER of the particular rather than the general, the actual, rather than the ideal. 'No two days are alike, nor even two hours; neither were there ever two leaves of a tree alike since the creation of the world.' His greatest originality lies in this belief and in his attempt to enshrine the precise time of day on canvas and the freshness of the English weather. 'I *like* de *landscape* of *Constable* . . . but he makes me call for my great coat and umbrella.' Fuseli's praise of Constable underlines the latter's success in depicting the shifting and watery quality of the weather. For Constable tried to achieve not only truth to nature, truth to what he actually saw in front of his eyes without selection or rejection, but also truth to the atmosphere, in a strictly meteorological sense. He painted the freshness and sparkle of the landscape under sun and rain. He took to heart Benjamin West's advice, 'Light and shadow never stand still'. In a letter to C. R. Leslie, his first biographer, Constable wrote in 1833 that Lady Morley had said of one of his pictures, 'How fresh, how dewy, how exhilerating!' and he added, 'I told her half of this, if I could think I deserved it, was worth all the talk and cant about pictures in the world.'

Constable's is a revolutionary art. In its time it was radical and uncompromising, going against the accepted conventions of his contemporaries and immediate predecessors. Eighteenth-century English landscape painters had produced pictures that were usually generalized and idealized depictions of nature, based on their study of pictures, rather than their study of the actual landscape. Often they were pale imitations or pastiches of Claude; sometimes they derived from the work of Dutch seventeenth-century landscapists such as Ruisdael; always these painters were, in Constable's own words—strictures, in fact, on his own early work—'running after pictures and seeking the truth at second hand'. They followed certain accepted conventions about how foliage should be painted, how the composition should be built up and organized, what colours should be used, what should be included and what should be left out. Constable rejected all this. He went to nature at its source and tried to forget that he had ever seen a picture before. Like his contemporary, William Wordsworth, he was doing something new, something which had never been done before, and, as Wordsworth had rejected the poetic diction and conventions of the Augustan poets, Constable rejected the pictorial language of eighteenth-century landscape painters. He recognized that he was breaking new ground and realized that his chosen path was hard. In his Preface to the *English Landscape Scenery*, a series of engravings in mezzotint after his work published from 1830, he wrote: 'In art, there are two modes by which men aim at distinction. In the one, by a careful application to what others have accomplished, the artist imitates their works, or selects and combines their various beauties; in the other, he seeks excellence at its primitive source, nature. In the first, he forms a style upon the study of pictures, and produces either imitative or eclectic art; in the second, by a close observation of nature, he discovers qualities existing in her which have never been portrayed before, and thus forms a style which is original.'

This is not to say that Constable rejected all the landscape art of the past. He

worshipped Claude and Ruisdael and venerated Richard Wilson because he saw in the work of these artists their direct inspiration from nature. It was the copyists and imitators, such as his contemporary John Glover, the 'English Claude', whom he despised. In fact, there is a paradox at the centre of Constable's art. He was a great innovator, but he also wanted to produce paintings that would take their place in the tradition of European landscape art. This is one of the reasons why he laboured at his large six-foot canvases for the Royal Academy exhibitions in the 1820s. He wrote to his great friend, Archdeacon John Fisher of Salisbury, in 1821, ' . . . I do not consider myself at work without I am before a six-foot canvas . . . '. His almost lifelong struggle, never perhaps fully resolved, was to produce large exhibition pictures such as the *Haywain* (Plate 24) and the *Leaping Horse* (Plate 41), without losing the spontaneity and immediacy of the first sketch. His usual practice was to work in the summer in the fields, painting directly from nature, normally oil sketches on board or paper, and during the winter and early spring he worked in his studio in London, seeking to inject into his large painting of the year all the vividness and freshness of these sketches.

John Constable was born on 11 June 1776, at East Bergholt in Suffolk, the fourth child of Golding Constable. Although often described as a miller's son, his father was a mill owner rather than a miller. He owned mills at Flatford and Dedham and was prosperous. The family and village life in which Constable grew up was of the kind described by Jane Austen in her novels; the social status of Constable's parents was sufficiently high for them to be invited to dine at the large houses in the neighbourhood. When Golding Constable died in 1816 he left an estate worth about £13,000. John Constable should have taken over the family business, for his elder brother was mentally deficient, but in fact John's youngest brother, Abram, eventually carried on with running the mills. At the age of seven, John was sent to a boarding school about fifteen miles from East Bergholt and from there he went on to a school at Lavenham where the master in charge is said to have flogged his pupils unmercifully. Constable was taken away and sent to the grammar-school at Dedham, walking to school each day through the shaded lane depicted in the *Cornfield* (Plate 3) in the National Gallery, where he was taught by the able and conscientious Dr Grimwood.

From the first, Constable felt a deep love for the landscape of the Stour valley, and especially for the small area, about six miles long and two miles wide, around East Bergholt and Dedham. Years later, in 1821, he wrote to John Fisher, ' . . . I associate my "careless boyhood" with all that lies on the banks of the Stour. Those scenes made me a painter, and I am grateful—that is, I had often thought of pictures before I ever touched a pencil.' Although at first intended for the Church, and later working for a year in the mill near Pitt's Farm, which appears in his painting of *Golding Constable's Kitchen Garden* (Plate 10), Constable, from a very early age, wanted to be a painter. He painted in the fields around his home, often accompanied by the amateur artist, John Dunthorne, the father of another John Dunthorne, who later helped Constable in his studio. David Lucas, Constable's engraver, commented on their practice. 'Both Dunthorne [senior] and Constable were very methodical in their practice, taking their easels with them into the fields and painting one view only for a certain time each day. When the shadows from objects changed, their sketching was postponed until the same hour next day.'

Constable's parents, though perplexed by his ambitions, did not fight for long against them. His mother, however, shrewdly realized that his hopes of making a

living from landscape painting were small, and in her letters to him when he was studying in London, and later working as an artist, she continually urged him to look after his own financial interest and encouraged him to concentrate on portraiture. In 1809 she wrote to him, ' . . . dear John how much do I wish your profession proved more lucrative, when will the time come you realize ! ! !' Many artists with ambitions to be landscape or subject painters grumbled that money could only be made from portraiture or 'fiz mongering'. Indeed, even in Constable's lifetime, landscape painting, or at least landscapes of humble and ordinary nature, was not regarded as worthy of a place in the higher branches of art. It is partly a measure of Constable's achievement, which did not bear fruit in his lifetime, that such painting finally became acceptable. It also partly explains why Constable found such difficulty in selling his works. He did try to supplement his income by portraiture, especially before the 1820s, but his heart was not in it.

The years of Constable's boyhood and early youth were crucial for his development as an artist. Throughout his life he returned to East Bergholt in the summer months to draw fresh inspiration from the scenes he knew so well and his finest paintings all depict the Stour valley and other parts of England that he both knew well and which harboured for him happy associations. He could not, like Turner, go anywhere and paint any landscape or scenery. He needed to be deeply immersed in a place before he could paint it with true feeling and conviction. He wrote to John Dunthorne from London in 1799: 'This fine weather almost makes me melancholy; it recalls so forcibly every scene we have visited and drawn together. I love every stile and stump, and every lane in the village, so deep rooted are early impressions.'

Constable loved not only the landscape of the Stour valley, but also all the human activity and industry connected with it. C. R. Leslie noted that 'His nature was peculiarly social and could not feel satisfied with scenery, however grand in itself, that did not abound in human associations.' This interest in a landscape where man worked in harmony with his surroundings is quite different from the figures in landscapes found in earlier paintings, especially the Italianate ones. In these the figures are either taken from classical mythology or the Bible, and enact some story not especially connected with the scenery, or they are artificially posed figures put in solely as an aid to the composition, to accent a viewpoint or to draw the eye to a particular part of the picture. Constable's figures are not only at home in the landscape, whether working or merely walking, standing or sitting, but they are also placed naturally. The figures in his Hampstead paintings, such as *Hampstead Heath : Branch Hill Pond* (Plate 33), bear this out. He was especially interested in the activity of the Stour valley. In the *White Horse* (Plate 23), the horse which pulled the barges is being ferried across the river where the towpath crosses from one side to the other, and in the *Flatford Mill, on the River Stour* (Plate 20), the horse is being linked up again with the barge after having just crossed the river. In the *Leaping Horse* (Plate 41), the horse which pulls the barges is jumping one of the low fences which keep the cattle from straying. In *Boat-building near Flatford Mill* (Plate 19), the barges are being built by the side of the river, and in *Spring—East Bergholt Common,* ploughing is in progress with a windmill on the right. Constable was always at pains to be accurate in his details. He once criticized a painting by another artist on the grounds that the plough depicted in it was not of the sort that was found in the county which was portrayed. His brother, Abram Constable, wrote to Leslie after

John's death. 'When I look at a mill painted by John, I see that it will *go round*, which is not always the case with those by other artists.' Constable loved these humble scenes and found in them the subject-matter of all his paintings.

In 1796 Constable met J. T. Smith, best known as the biographer of Nollekens, and his first drawings of cottages, hesitant, ill-drawn and amateurish, are influenced by Smith's depictions of the same subjects. Indeed, Constable's early work is not of high quality, and he was not gifted with easy facility. The rudiments of correct drawing were a struggle and his early paintings are weak in execution. The fact that painting did not come to him easily conditioned his art to a large extent and, paradoxically, accounts for much of the quality in his mature work. For it gives to his painting a directness and integrity and an absence of mannerisms, at least in his finest work, which might well have been lacking had he been an infant prodigy. With Constable, his limitations were also his great strengths. Writing to Dunthorne from London in 1800 he said, ' . . . I find it necessary to fag at copying, some time yet, to acquire execution.' When he went to the Royal Academy schools, in 1799, he spent hours producing painstaking and infinitely dull academic nudes, but this practice, though it must have given little encouragement to his teachers, did eventually give him a sound grasp of form.

The early influences on Constable's painting were crucial to his later development. By 1796 he had met Sir George Beaumont, one of his earliest patrons, and later he saw and fell in love with Beaumont's little Claude of *Hagar and the Angel*, which is now in the National Gallery. Beaumont is said to have been so attached to the painting that he had a special box made for it and carried it around with him wherever he went. Constable copied it more than once, and its composition is reflected in his *Dedham Vale* of 1802 (Plate 2) and in the later, larger picture of 1828 in the National Gallery of Scotland. He was also probably introduced to the work of Richard Wilson through Beaumont, whose friendship and patronage formed a kind of prototype of the discerning admiration, not unmixed with perplexity, which Constable found later in the patronage of Bishop Fisher of Salisbury and even, at times, in the friendship of Archdeacon Fisher, the Bishop's son. For nearly all of Constable's limited circle of friends and patrons could not understand why he did not follow more the practice of his contemporaries.

At this time Constable read Gessner's *Essay on Landscape* and followed the advice he found in it to copy from landscape engravings. He was particularly fond of Ruisdael's etchings, which he both frequently copied and acquired, nearly ruining himself financially in the process. He met Joseph Farington, the influential *éminence grise* of the Royal Academy and patron and friend of young artists, who helped him meet some important people. Constable also admired Gainsborough, and writing to J. T. Smith from Ipswich in 1799, he said, ''Tis a most delightful country for a landscape painter, I fancy I see Gainsborough in every hedge and hollow tree.' Gainsborough's influence can be seen in some of Constable's early work, such as the *Wood* in 1802 (Plate 5) in the Victoria and Albert Museum, where the treatment of the foliage and light staining of the canvas with thin pigment is reminiscent of Gainsborough, and although his painting gradually lost all similarity to the work of Gainsborough, Constable retained a great affection for this artist, whose attachment to landscape and to the Suffolk countryside deeply impressed him. Although Gainsborough had no interest in the particular, his deep feeling for landscape is apparent in his paintings. Constable, towards the end of his life, remarked that Gainsborough's 'object was to deliver a fine senti-

ment, and he has fully accomplished it'. Constable's long apprenticeship in his art may seem bewildering when it is set against his obvious originality and rejection of the convention of his time, but he was continually aware of the importance of intelligent study of the art of the past, an awareness which is curtly summed up in his contention of 1836, right at the end of his life, that 'a self-taught artist is one taught by a very ignorant person.'

In 1801 Constable made a tour of the Derbyshire Peak District, but the delicate sketches he made there, although competent and attractive, show no foretaste of what was to come. The year of 1802, though not one of outstanding achievement in his art, marks an important step forward in the development of his ideas and the maturing of his aims and ambitions. The watercolour of *Windsor Castle from the River* (Plate 4), painted in May, with its reminiscences of Samuel Scott and Canaletto, still shows him 'running after pictures and seeking the truth at second hand,' but on the 28th of the same month Constable wrote to Dunthorne, 'I shall return to Bergholt, where I shall endeavour to get a pure and unaffected manner of representing the scenes that may employ me. . . . There is room enough for a natural painture. The great vice of the present day is bravura, an attempt to do something beyond the truth. Fashion always had, and will have, its day; but truth in all things only will last, and can only have just claims on posterity.' The word 'painture' is that actually written by Constable. It has often been read as 'painter', but Constable probably meant by it 'style of painting' or 'kind of painting' rather than 'painter'. His convictions grew and strengthened, and a year later, he wrote to Dunthorne. 'I feel now, more than ever, a decided conviction that I shall sometime or other make some good pictures.'

Although the next few years in Constable's life are not well documented by his own writings, it is clear that from this time he began to paint direct studies from nature with the aim of putting down exactly what he saw. He did not want any preconceived notions of what a picture should look like, or how it should be painted, to intervene between himself and the landscape in front of him. His method was both scientific and charged with feeling. He sought to find a pictorial language that would approximate as closely as possible to the images which his eye received. This meticulous fidelity to nature can be seen in the two views he painted from the first-floor window of his father's house at East Bergholt, *Golding Constable's Kitchen Garden* (Plate 10) and *Golding Constable's Flower Garden* (Plate 11) of about 1810. It was a long struggle, but particularly noticeable if we follow the sketches he made from about 1802, with *Dedham Vale,* up to the *Boat-building near Flatford Mill* of 1815 (Plate 19).

The *Dedham Vale* of 1802 already rejects many well-worn conventions of execution and method, for Constable has already sought to imitate as closely as possible the different greens in nature and to get away from the predominant brown tone favoured by the connoisseurs. Leslie reported that 'Sir George (Beaumont) recommended the colour of an old Cremona fiddle for the prevailing tone of everything, and this Constable answered by laying an old fiddle on the green lawn before the house.' But *Dedham Vale* still has rather conventional passages, especially in the foliage of the trees, in the flat and uninteresting sky, which is no more than a stage backdrop behind the landscape, and in the composition itself, which derives very closely from Claude's *Hagar*.

In 1806 Constable made a tour of the Lake District, a tour almost obligatory for landscape painters of the time. His oils and watercolours of Borrowdale and

Keswick are interesting and significant, because although Constable claimed that the mountains 'oppressed' him, and although he obviously did not feel at home in the awesome grandeur of the Lakes, his work is not like the conventional 'picturesque' views produced by contemporary artists. They are much rougher and freer in handling, emphasizing the weather effects and watery atmosphere of the cloudy mountains. He made notes on the back of many of his sketches referring to the time of day and prevailing weather conditions, a practice which was to continue throughout his life, and notably in the cloud studies of the early 1820s. For example, on the back of *View in Borrowdale* (Plate 7), where there is a rough pencil sketch, he wrote, 'Borrowdale 4 Octr. 1806 Noon Clouds breaking away after Rain.'

The next crucial stage comes between 1810 and 1816, when Constable spent most of the summers at East Bergholt, sketching in the fields and surrounding countryside. These were also the years in which his long drawn out courtship of Maria Bicknell was in progress. The *Village Fair* of July 1811, belongs to this period, as do the amazingly direct studies, *Barges on the Stour* (Plate 14) and *Flatford Mill from a Lock on the Stour* (Plate 15), both probably painted in the same year of 1811. In the last two oil sketches Constable has obviously tried to rid his mind of any preconceived notions about pictures. The brushwork is direct and spontaneous, almost as if he was not aware of it at the time, so engrossed was he at putting down what he saw. The sky in both studies is as thickly and strongly painted as the landscape itself, forming an integral part of the whole. Skies were to become one of the major preoccupations of his mature work. There is none of the conventional, slightly flaccid brushwork which is found in the *Dedham Vale*, but each strong stroke seeks to transmit what he actually saw, to be a visual equivalent of part of the object it depicts. Constable is not interested here in pleasing effects of light, tone and colour; his intense experience before nature is almost crudely transferred to the picture. There is a feeling of direct contact with the landscape and the quality of freshness and sparkle is achieved. One senses, from these studies, that the act of painting was, for Constable, in the final analysis, of more significance than the finished work. Constable himself said that 'Painting is with me but another word for feeling.'

After sketches such as these, the *Boat-building near Flatford* (Plate 19), of 1815, is another important milestone. Here he aimed to paint, entirely in the open air, and in front of the motif, a finished picture, not merely an experimental study or sketch. It was one of his earliest attempts to inject into a finished picture the direct spontaneity of a sketch. Although the colouring is faithful and the details are individually almost perfect in their fidelity, the whole does not hang together satisfactorily. It is a brilliant accumulation of details, rather than a painting with an overall theme. There is no prevailing source of light which illuminates the separate parts, welding them into a coherent whole. The *Flatford Mill, on the River Stour* (Plates 18, 20 and 22), of 1817, can be criticized in the same way, but it is more advanced in that the sky is more predominant and governs the prevailing tone of the painting. Constable was continually aware of the importance of the sky in landscape painting. In 1821, quoting Sir Joshua Reynolds, on the land-scapes of Titian, Salvator Rosa and Claude, he wrote, 'Even their skies seems to sympathise with their subjects', and continuing with his own thoughts, he said, 'I have often been advised to consider my sky as a "white sheet thrown behind the objects." Certainly, if the sky is obtrusive, as mine are, it is bad; but if it is

evaded, as mine are not, it is worse; it must and always shall with me make an effectual part of the composition.'

These early years of development, from 1811 to 1816, formed a springboard from which Constable moved on to his big exhibition pictures, the pictures which he himself regarded as his most important and lasting works. It was during these years that Constable extensively used the oil sketch, sometimes on canvas, but usually on paper or board, which gave a light-brown basis on which to work. The oil sketch was not new, but Constable used it as a more significant working tool than earlier artists. He used it not only, in fact rarely, to work out compositions, as it had mainly been used previously, but almost as an end in itself. I use the word 'almost', because Constable never regarded the oil sketch as a finished picture or as a work that could be exhibited. He felt that it had certain drawbacks, for 'In a sketch there is nothing but the one state of mind—that which you were in at the time.' But he worked out his problems with it, rather as a mathematician might use a blackboard, or as a scientist might use the equipment in his laboratory. Indeed, the comparison with the scientist is not as far-fetched as it might sound: Constable's art was scientific, and his oil sketches can be seen as his experiments. He himself wrote, 'In such an age as this, painting should be understood, not looked on with blind wonder, nor considered only as a poetic aspiration, but as a pursuit, legitimate, scientific and mechanical.' Artists before Constable had used oil sketches in much the same way—artists such as the Welsh painter Thomas Jones and the French painter Pierre Henri de Valenciennes—but when these artists had turned to finished pictures they reverted to the standard conventions of the classical Claudian composition. Constable tried to transport into his finished work all the directness of his sketches, almost to draw his large pictures back into the sketch, rather than to merely use his sketches as aids to composing large pictures, or as interesting experiments to be abandoned when a finished picture was taken in hand.

His sketches were rarely composed as one might compose a painting in the studio. Often they are of corners of nature, unsatisfactory as compositions, but effective because of their directness. His *View at Salisbury from Archdeacon Fisher's House* has a cut-off, awkward viewpoint, but it is far more faithful to what we actually see than the most carefully composed painting one could imagine. One can picture Constable sitting at a first floor window looking out on the garden and the trees beyond. There is nothing in the least artificial or selective about the painting.

Although these were early years in his development, Constable was forty in 1816. He married in this year Maria Bicknell after a long courtship which had started before 1811 and which had been relentlessly opposed by her grandfather, Dr Rhudde, the vicar of East Bergholt and a weighty influence in the village. His married life was extremely happy, shadowed only by the illness of his wife and her early death in 1828, after which Constable's sometimes tetchy nature grew more melancholy and his inward-looking isolation from the world around him grew more marked. Constable, in fact, was never a worldly man in the sense that he found it an easy place to live in. His continual and stubborn refusal to compromise or to sacrifice an ounce of his integrity meant that his relationships with both patrons and contemporary artists was often strained and hostile. Early on in London he made friends with an artist called Ramsay Richard Reinagle, but he soon turned against both Reinagle's art and his friendship. Constable had a biting

tongue when roused, and fits of bitterness, together with a nature that could be at times both self-righteous and self-pitying, did not make things any easier. There is some truth in his assertion to Fisher that 'The field of Waterloo is a field of mercy to ours', but there is little doubt that he made the situation worse for himself. He refused to paint as his prospective patrons wanted, even to compromise fractionally, and he always asserted that he painted only for himself; and yet he still desired recognition and was naively pleased if any critic or fellow artist praised his work. But he found solace in his work and his family and few close friends, and these saved him from himself to a certain extent. 'I have', he wrote to Fisher in 1823, 'a kingdom of my own both fertile and populous—my landscape and my children.'

Constable did not make much money from his paintings, and certainly not enough to live on until at least the mid 1820s. In the early 1830s he could make as much as £700 or £800 a year, but some of his contemporaries could make as much as this from one painting. In 1816 he was lucky if one of his landscapes made £30, if it sold at all. After his father's death in 1816 he received about £200 a year from the family estate and ironically, his wife's grandfather, the stern opponent of his marriage, left a fortune to Maria only just before she herself died. This meant that the last years of Constable's life were spent in financial security.

In 1819 Constable was elected to be an Associate of the Royal Academy. He was not made a full Academician until 1829, when he was in his fifty-third year. Before this he had seen, not without bitterness, lesser and younger men elected, and it is a measure both of the lack of understanding of his art, and of the low esteem in which landscapes of humble nature were held in academic circles, that he had to wait so long. In later life he took part in Academy business and even served on the hanging committee, but he was on the whole cynical about his fellow academicians. But he did recognize that the Academy was the one place where recognition was possible for a living English artist. Patrons preferred conventional pictures; dealers usually only bought and sold 'old masters'; engravers and printsellers took the bulk of the profit from engravings; but in the Academy Constable's name could become known. In Somerset House, where the exhibitions were held, it was difficult to really see a picture unless it was exhibited 'on the line', the position reserved for academicians, and unless an artist produced large pictures it was unlikely that he would be noticed. This is perhaps one of the main reasons why Constable turned to large pictures in 1819, when he exhibited the *White Horse* (Plate 23) at the Academy. This is a successful picture which shows the closed-in composition of many of Constable's large works. There is no long or distant view, but a close-up of the life of the Stour with trees closing off the composition at the back. It has the natural freshness of all Constable's best work, together with telling detail and rich passages of thick pigment. Fisher recognized its merit and bought it for £100, partly, it must be admitted, out of a desire to help his struggling friend's finances. He wrote to Constable in 1820 when it was installed in his house, 'My wife says that she carries her eye from the picture to the garden and back and observes the same sort of look in both.'

The following succession of large exhibition pictures, meant by Constable to take their place in the great European tradition of landscape painting stretching back to Ruisdael and Claude, were original not only in their handling, but also in their subject-matter. It had previously been thought, especially in England in the eighteenth century in academic circles, that paintings of ordinary nature were not

grand enough to be placed in the highest rank or judged by the highest standards. They should be idealized or generalized depictions of nature, and perhaps should be ennobled by figures from classical or biblical history. Sir Joshua Reynolds— the first President of the Royal Academy and greatly venerated by Constable for his services to British art—had claimed that 'common' or 'mean' nature could not form the subject of great pictures. But Constable wanted to paint 'common' nature because he considered it possessed both noble and moral, even divine, elements. He said that there was nothing 'ugly' in nature, and he believed that the more faithfully it was represented, the more noble was the result. It was a conviction which is shown by his admiration for Gilbert White's *Natural History of Selborne,* a study of the natural life in the small village in Hampshire and its surrounding woods. 'The single page alone', Constable wrote, 'of the life of Mr White leaves a more lasting impression on my mind than that of Charles the fifth or any other renowned hero—it only shows what a real love for nature will do. . . .'

In 1821 Constable exhibited the *Haywain* (Plate 24) at the Royal Academy. Typically, it was called in the catalogue, *Landscape: Noon*, demonstrating Constable's interest in the precise and particular time of day. Springing from a number of studies and oil sketches, notably of Willy Lott's house, it evolved through the full-size sketch in the Victoria and Albert Museum, and from this time forward it became Constable's practice to produce a full-size study in preparation for his final exhibited work. Today the *Haywain* is so well known that it is difficult to appreciate its full originality and merit. The composition has all the grandeur of a great picture by Ruisdael, to which it was compared by one newspaper critic, but it has also all the life and vigour, the freshness and sparkle, of a landscape under changing skies. In achieving this freshness, Constable inevitably sacrificed 'finish', that is the detailed surface which was far more popular among connoisseurs of the time. In fact, one of the main contemporary criticisms of Constable was that his pictures were 'unfinished'. Even when he was painting *Salisbury Cathedral from the Bishop's Grounds* for the Bishop, John Fisher urged him to put a little more 'niggle' in it to please his patron. Constable made his own feelings plain when he wrote to Fisher in 1823 about *Salisbury Cathedral*. 'I have not flinched at the work, of the windows, buttresses, etc. etc., but I have as usual my escape in the evanescence of the chiaroscuro.'

Of his large exhibition pictures, the *Haywain* is Constable's most complete statement of his artistic aims. In it his art reached its high watermark. If it is not completely successful, it is only because the complete fidelity to nature which Constable hoped to achieve is not possible with paint on canvas. Through the long process of composition and execution some of the spontaneity of the first contact with nature is bound to be lost, but in the *Haywain* the freshness is sustained as far as possible. Thenceforward Constable moved, if anything, away from complete fidelity to nature. His painting becomes more obviously emotion- ally charged, but also more mannered, and his personal handwriting becomes more and more marked. The almost total accord between artist and landscape found in the *Haywain* is lost and an intermediary element becomes more notice- able, the artist's feelings, passions, and personal handling.

The *Haywain* found more favour in France than in England. Charles Nodier, who saw the painting at the Royal Academy in 1821 wrote, 'The Palm of the exhibition belongs to a large landscape by Constable to which the ancient or modern masters have very few masterpieces to put in opposition.' In 1822

Constable wrote to Fisher, 'I have had some nibbles at my large picture . . . I have a *professional* offer of £70 for it to form part of an exhibition in Paris.' He had originally asked £150 for it, not an excessive price when it is remembered that it represented almost a whole year's work, and was unwilling, as he put it, 'to allow myself to be knocked down by a Frenchman'. The latter was the dealer Arrowsmith, who did eventually buy the picture—together with the *View on the Stour,* exhibited at the Royal Academy in 1822, and a small study of Yarmouth—for £250. The *Haywain* was exhibited at the Paris Salon in 1824, where it won the gold medal. It had been admired by such eminent French artists as Géricault and Delacroix, and there is no doubt that the freshness and naturalism of his paintings influenced some French landscape painters, notably Paul Huet. Between 1824 and 1830 quite a number of his paintings found their way to France, and although the vogue for Constable declined after 1830, his work made an impact on the course of French landscape art much earlier than it did in England, where, even at Constable's death, his work was both little known and generally misunderstood.

Constable's series of cloud studies were executed mainly at Hampstead in 1821 and 1822. These were attempts to understand more fully the actual form and shape of the different types of clouds so that he could bring greater verisimilitude to his finished paintings. They often have detailed notes on the back, such as '5th Sept. 1822, 10 o'clock, morning, looking south-east, brisk wind at west. Very bright and fresh grey clouds running fast over a yellow bed, about half way in the sky. Very appropriate to the Coast at Osmington.' It seems likely that Constable had read Thomas Forster's *Researches about Atmospheric Phenomena*, first published in 1812 and reprinted in 1815 and 1823. From this work Constable would have become familiar with the classification of clouds based on their visible differences of shape. He also might have known Howard's *The Climate of London*, of 1818–1820, where an *Essay on Clouds* formed the first chapter of the first volume. These scientific sketches of clouds bear out forcibly Constable's contention that the 'sky is the keynote, the standard of scale and the chief organ of sentiment' in a picture. The lessons he learnt by making them can be seen if one compares the *Dedham Vale* of 1802, with its rather weak two-dimensional sky, with the *Vale of Dedham* of 1828, where the clouds are recognizable cumulus formations and where the sky casts its light and freshness over the whole picture.

In 1825 Constable exhibited the *Leaping Horse* (Plate 41) at the Royal Academy. The full-size study for the painting is much more worked up and thickly painted than the sketch for the *Haywain*, and there is, in fact, little difference in handling between the sketch and the exhibited work. A comparison between the finished work and the sketch also shows how Constable, notwithstanding his fidelity to nature, was quite prepared to change his composition if he felt that it provided a better balanced painting. In the sketch of the *Leaping Horse* a willow tree is on the right of the horse, while in the finished painting it has been moved to the left, and there are changes, too, in the barges on the left and in the left foreground, where a wooden beam is brought into the finished picture to help give the impression of depth and recession into the landscape. But however much Constable changed the composition, the subject-matter remains the same: ' . . . the sound of water escaping from Mill dams . . . willows, old rotten Banks, slimy posts and brickwork. I love such things . . . as long as I do paint I shall never cease to paint such Places.'

Despite Constable's attachment to the Stour valley, he also loved other places which were closely associated with his life and especially his own family; Weymouth and the nearby village of Osmington, where he spent his honeymoon in 1816; Salisbury, the home of his great friend John Fisher; Brighton, where his wife stayed often after 1824 because of her delicate health; and Hampstead Heath, his London home in the 1820s, where the fresh wind-blown heights above London inspired some of his freshest studies and paintings. Constable never travelled abroad, and had no desire to do so. He made only two major tours in England, and those at the beginning of his career—to Derbyshire and to the Lake District.

In 1829 Constable exhibited *Hadleigh Castle* (study, Plate 44) at the Royal Academy. This passionate and tortured painting may well reflect Constable's gloom and despondency following his wife's death the year before. It had its conception in a pencil sketch made in the summer of 1814, perhaps a conscious return to a time of happiness when he was seeking to marry Maria Bicknell against the wishes of her family. Constable, in fact, often returned to earlier sketches for his finished paintings, especially later in his career. The Stonehenge watercolour of 1836 derives from a sketch made in 1820. His *Valley Farm* of 1836 owed its origin to a sketch of 1813, and the *Cenotaph* of 1836, a tribute to Joshua Reynolds, goes back to a drawing made at Coleorton, the country home of Sir George Beaumont, in 1823. Constable may have been trying to recapture the inspiration of his earlier years, when his accord with nature was at its most spontaneous. It is certainly true that his mannerisms grew more marked as the years went by, and he injected into his works an almost feverish movement and passionate intensity that is evident in the brushwork—the staccato stabs of thick paint and the dragged specks of white pigment known as 'Constable's Snow'. He became more interested in broad masses of light and shade and less and less interested in the details and fidelity to appearance found in such works as *Flatford Mill, on the River Stour*. This can be seen clearly in the *Trees and a stretch of water on the Stour* (Plate 47), painted in the 1830s, where the sepia is applied in such broad masses that no details are apparent at all; and in *A river scene, with a farmhouse near the water's edge* (Plate 48), also of the 1830s, where the later manner of Constable is evident in the broken colour, the thick application of paint, the expressionistic handling and the consistent texture of the whole paint surface, made up of thin underpainting overlaid with dragged passages of thick pure paint. Here we notice not so much the subject of the picture, as the 'manner' of the artist, taking us one remove from appreciation of the landscape depicted and forcing our attention onto the handling. Constable himself was aware of this. He wrote to Fisher in 1830: 'My Wood (Helmingham Dell) is liked but I suffer for want of that little completion which you always feel the regret of—and you are quite right. I have filled my head with certain notions of *freshness* and *sparkle*—brightness—till it has influenced my practice in no small degree, and is in fact taking the place of truth so invidious is manner . . . which should always be combated—and we have nature (another word for moral feeling) always in our reach to do it with—if we will have the resolution to look at her.' This 'manner' was evident in some of the earlier sketches, such as *The Gleaners, Brighton* of 1824 (Plate 37), but it does not become apparent in his finished paintings to any marked degree until after the late 1820s, although its seeds are found in the *Leaping Horse* of 1825.

After 1830 Constable often refers to his love of nature and to his disillusion with painting. In 1831 he wrote, 'Nothing can exceed the beauty of the country—it makes pictures seem sad trumpery . . .' and two years later he made a more violent statement: 'Good God—what a sad thing it is that this lovely art—is so wrested to its own destruction—only used to blind our eyes and senses from seeing the sun shine, the feilds (sic) bloom, the trees blossom, and to hear the foliage rustle—and old black rubbed-out dirty bits of canvas, to take the place of God's own work.' Although Constable here was referring more to the landscapes of other artists, his own feeling of helplessness as an artist is also in evidence. Constable could never abide anything that was unnatural or sophisticated and when he sensed that his own paintings were not as true to nature as he wished he felt a sense of failure. His hatred of the unnatural extended to landscape gardens. He wrote in 1822, 'I do not regret not seeing Fonthill; I never had a desire to see sights, and a gentleman's park is my aversion.' He did paint a few country houses, however, such as the *Malvern Hall* (Plate 9), which has been dated both 1809 and *c*. 1820, though the earlier date is probably more acceptable. But he did such topographical work out of need to make ends meet, rather than out of love. When he painted *Englefield House,* in 1833, he had struggles with his patron, Richard Benyon de Beauvoir, and eventually was forced to paint out some cows he had placed before the house and replace them with deer, which were more aristocratic animals and more appropriate to 'a gentleman's park'. This picture was exhibited at the Royal Academy in 1833, and one critic 'told me it was only a *picture of a house,* and ought to have been put into the Architectural Room.' Constable's reaction was typical in its sharpness and revealing with regard to his ideas. He replied that it was 'a picture of a summer morning, *including a house.*'

It has often been argued that Constable's painting after the *Hadleigh Castle* of 1829 is, in its romantic expressionism, a new departure—a vivid and original last phase of mastery and achievement. Although his work in these last years, up to his death in 1837, is certainly as personal, if not more so, than his early work, and although its quality is far higher than the work of almost all his contemporaries, I believe that it represents a decline from his best work of the period 1810 to 1830. After his wife's death in 1828, his personal world of happiness gradually became emptier, even though he still derived great comfort from his growing children. John Fisher died in 1832, and his friendship with C. R. Leslie and later his name-sake, but no relation, George Constable, never filled the gap. His bursts of temperament increased with age rather than diminished, and even though he discovered Arundel in 1834, and claimed, 'I never saw such beauty in *natural landscape* before', and also found a new patron at Petworth, the Earl of Egremont, all this did not amount to a compelling source of new inspiration. Constable died, at the age of 60, on 31 March 1837.

Constable's major achievements lie in the years of development, from roughly 1802 and especially after 1810, until 1819, when he exhibited his first large 'six foot' canvas, the *White Horse,* at the Royal Academy, and then in the years of maturity of the 1820s, stretching from the *Haywain,* of 1821, up to *Hadleigh Castle,* the beginning of his last phase, in 1829. His art was circumscribed by narrow geographical boundaries and aims that were strictly confined, although intensely pursued. 'My limited and abstracted art', Constable wrote, 'is to be found under every hedge, and in every lane. . . .' But Constable has, with Turner, the distinction of being one of the two greatest landscape painters of this country,

and one of the greatest in the history of art of the whole world. When one looks at the *Haywain,* or the *Water-mill at Gillingham,* of 1827, with its amazing fidelity to nature, it is easy to think that his art is so obvious as to be almost trite. But in his time he was producing a faithfulness to nature that had never been attempted before in such a consistent and carefully worked out way, nor with such intensity of feeling and thoroughness of execution. The almost inevitable beauty and naturalism of his art is a measure of his achievement. For Constable, like all the greatest artists in landscape, saw something in nature which had never been noticed before and in transmitting what he saw to canvas he enriched and expanded not only subsequent landscape painting, but also everyone's appreciation of the natural scene. It is in part due to Constable that scenes of ordinary nature, fields, streams, trees and river banks under the ever-changing light of the sky, are appreciated and loved, not only in paintings, but also in themselves.

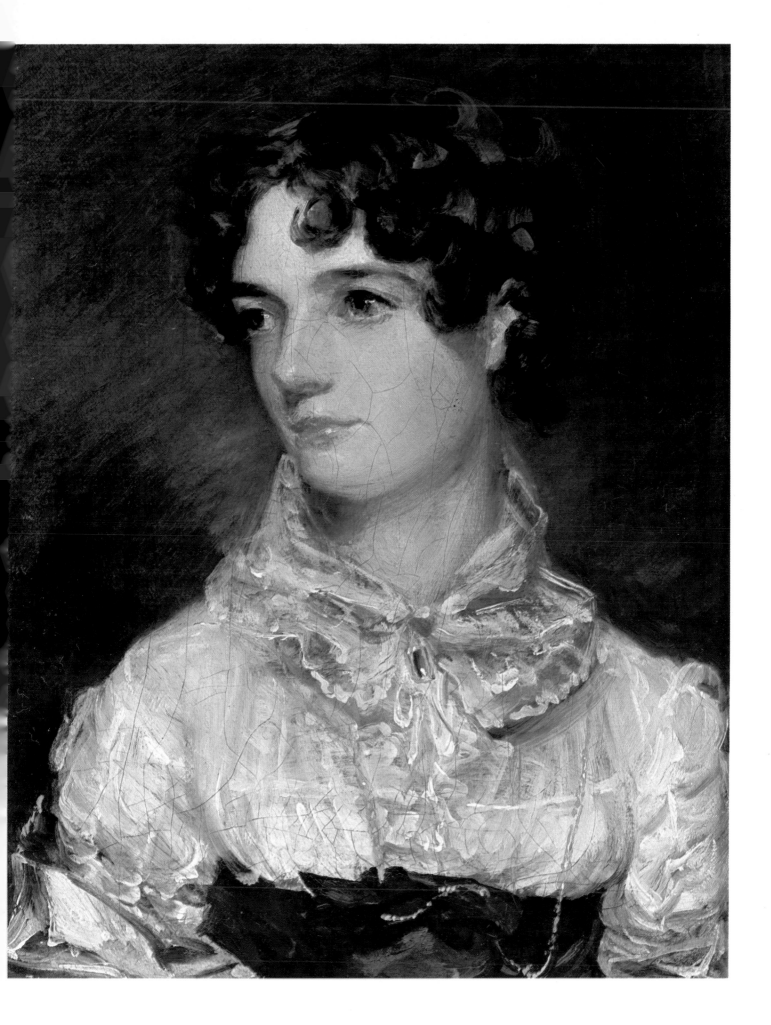

1. *MARIA BICKNELL, later Mrs. Constable.* Oils on canvas : $11\frac{7}{8} \times 9\frac{7}{8}$ ins. 1816. London, Tate Gallery

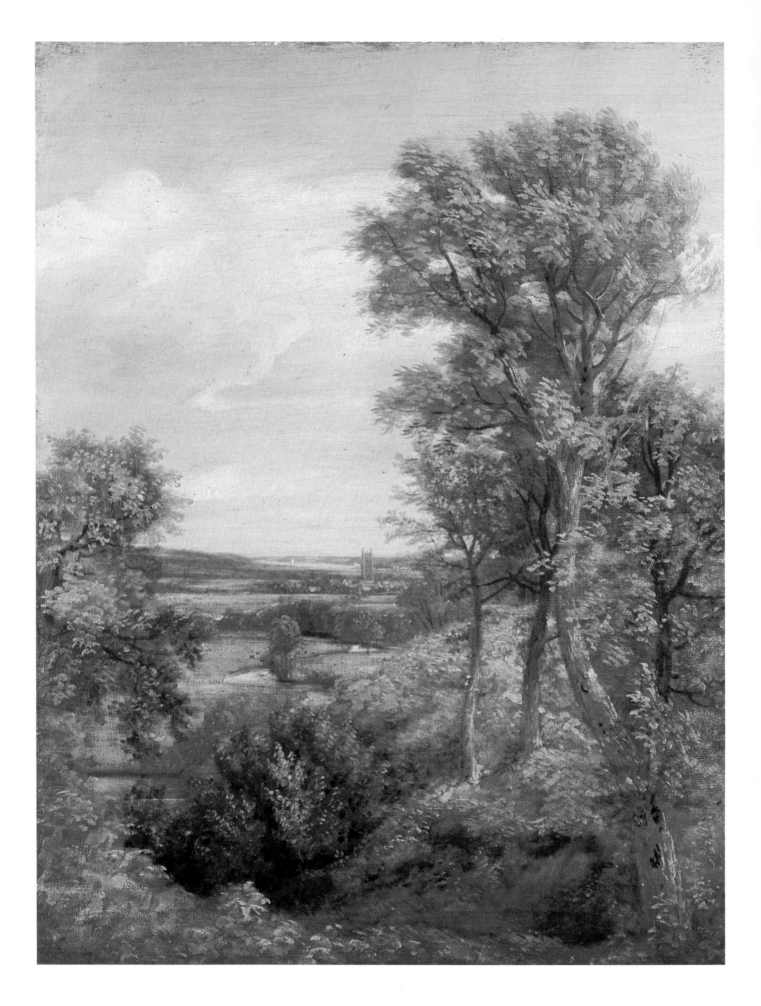

2. *DEDHAM VALE*. Oils on canvas : $17\frac{1}{8} \times 13\frac{1}{2}$ ins. September, 1802. London, Victoria and Albert Museum

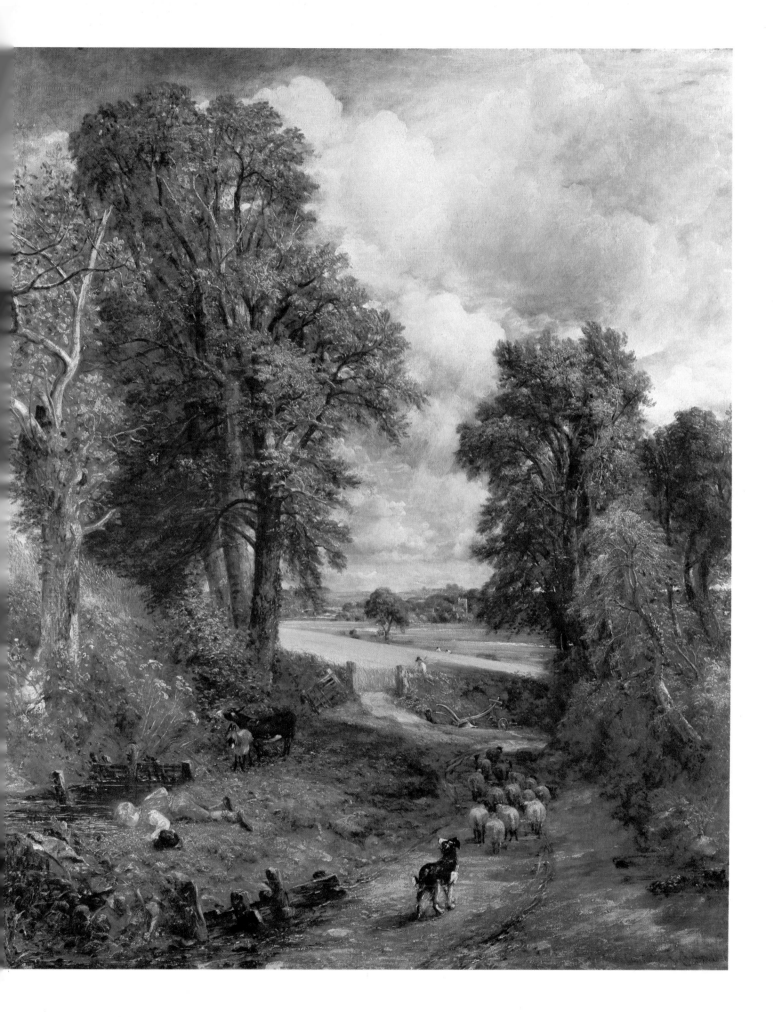

HE CORNFIELD. Oils on canvas : 56¼ × 48 ins. 1826. London, National Gallery

4. *WINDSOR CASTLE FROM THE RIVER*. Pencil and red chalk and water-colour : $10\frac{1}{4} \times 14\frac{3}{8}$ ins. May 17, 1802. London, Victoria and Albert Museum

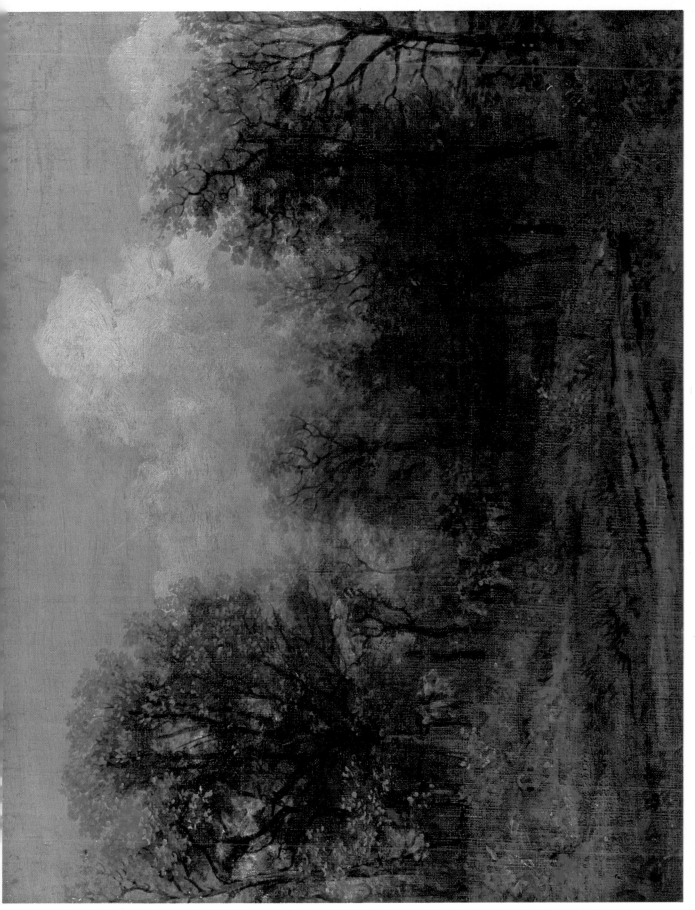

5. *A WOOD.* Oils on canvas : $13\frac{1}{2} \times 17$ ins. About 1802. London, Victoria and Albert Museum

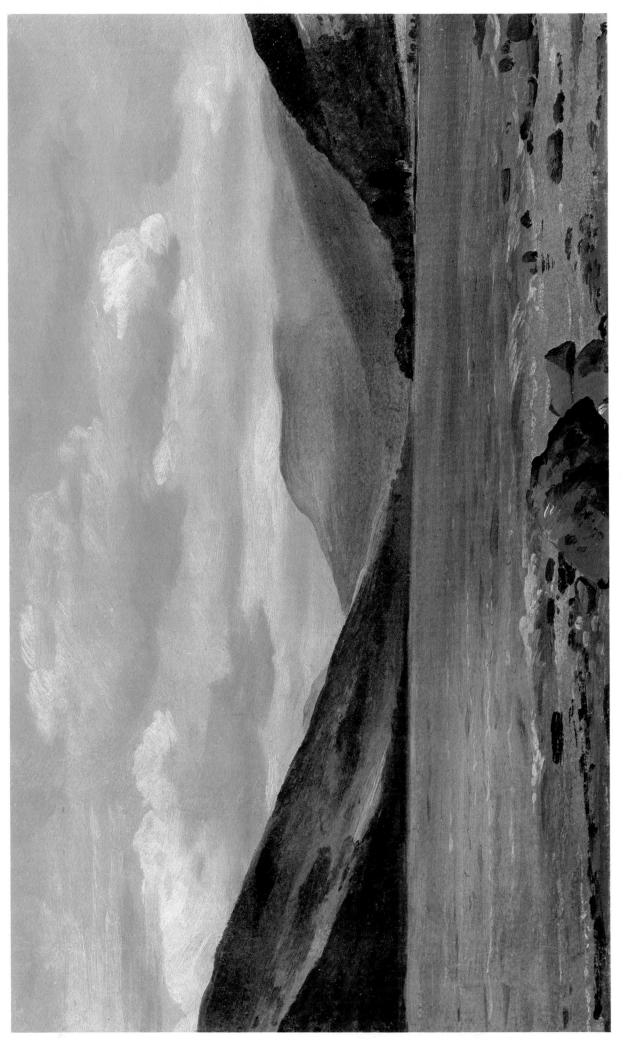

6. *LEATHES WATER, CUMBERLAND.* Oils on wood : $9\frac{3}{4} \times 15\frac{1}{2}$ ins. 1806. London, Tate Gallery

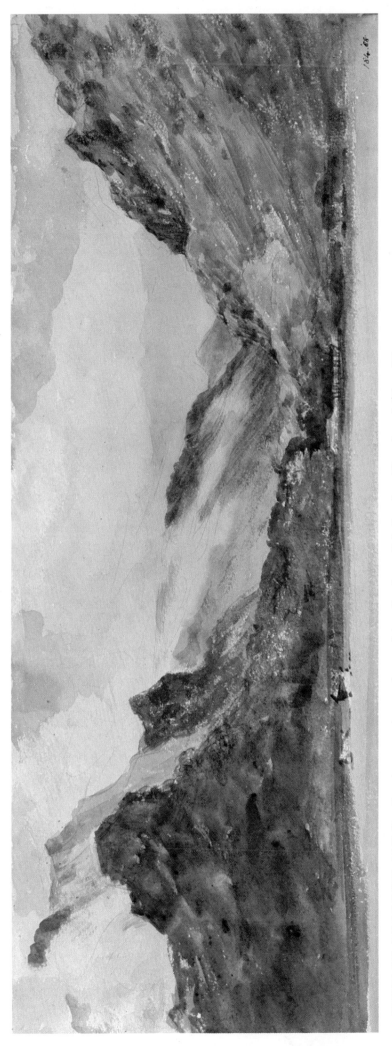

7. *VIEW IN BORROWDALE*. Pencil and water-colour : $5\frac{1}{2} \times 14\frac{7}{8}$ ins. October, 1806. London, Victoria and Albert Museum

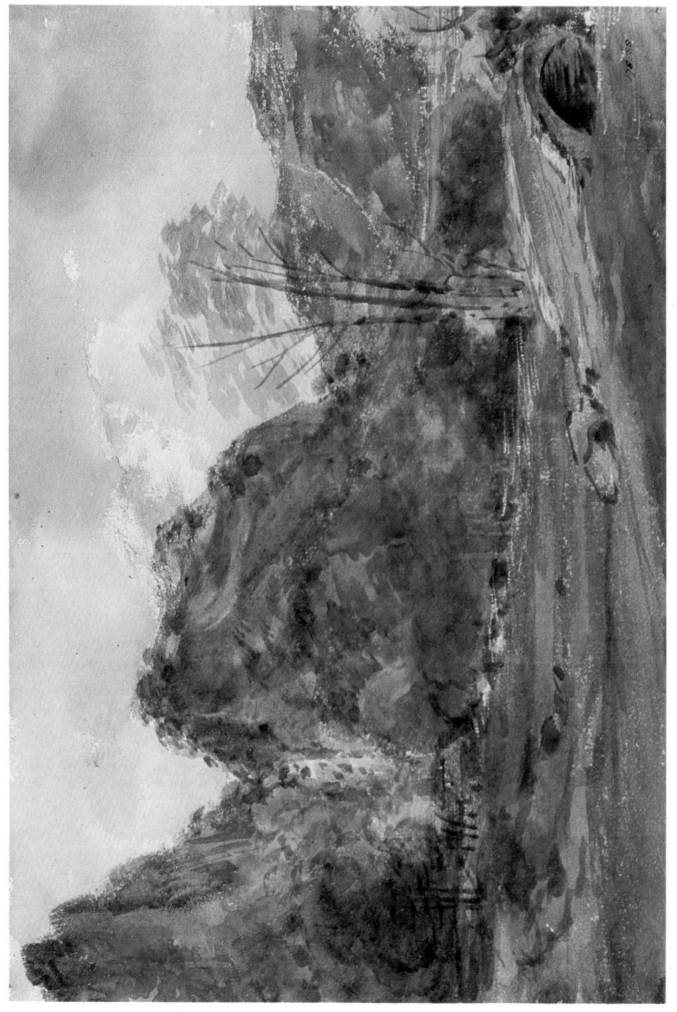

8. *LODORE*. Pencil and water-colour : $7\frac{7}{8} \times 10\frac{3}{4}$ ins. October, 1806. London, Victoria and Albert Museum

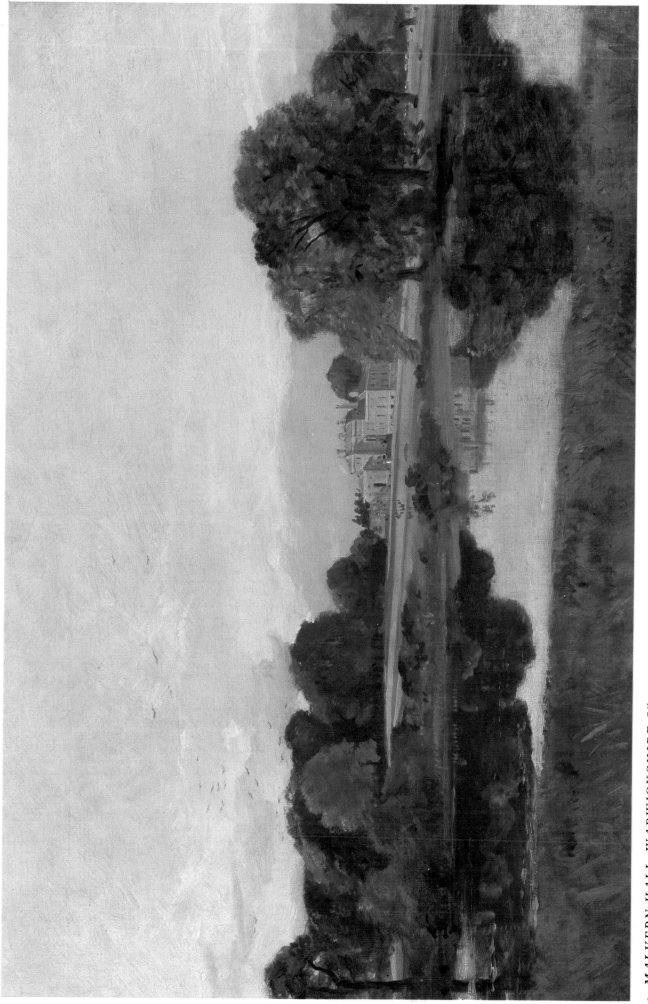

9. *MALVERN HALL, WARWICKSHIRE.* Oils on canvas : 20¼ × 30 ins.
Although dated 1809 on the back, some scholars have thought it later, about 1820–21. London, Tate Gallery

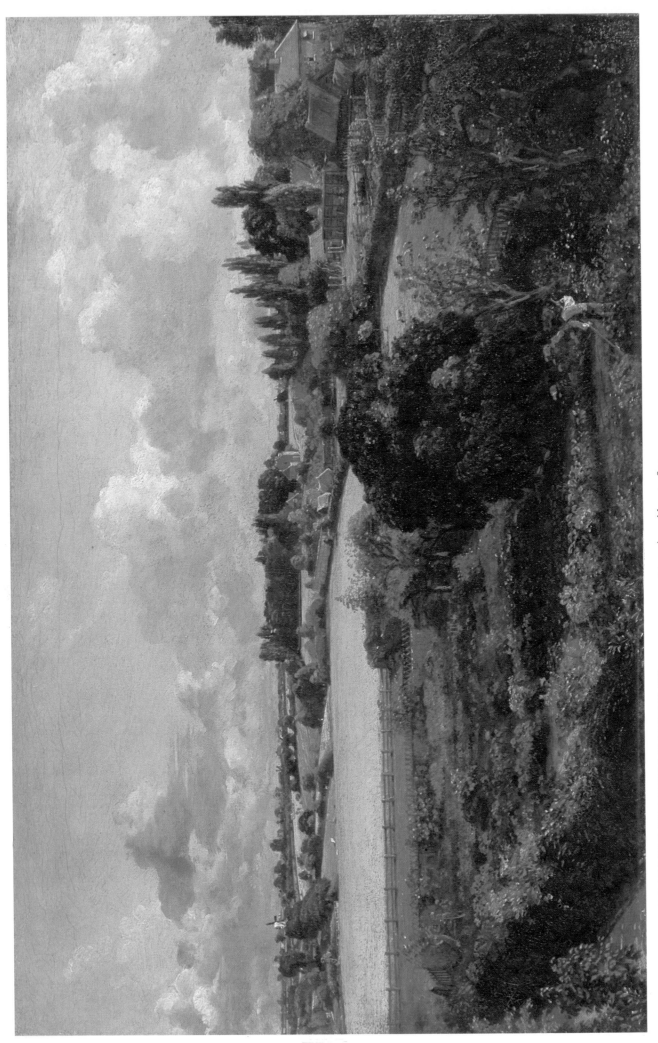

10. *GOLDING CONSTABLE'S KITCHEN GARDEN.* Oils on canvas : 13 × 20 ins. About 1810.
Ipswich Museum (Christchurch Mansion) (*Reproduced by permission of the Ipswich Museums Committee*)

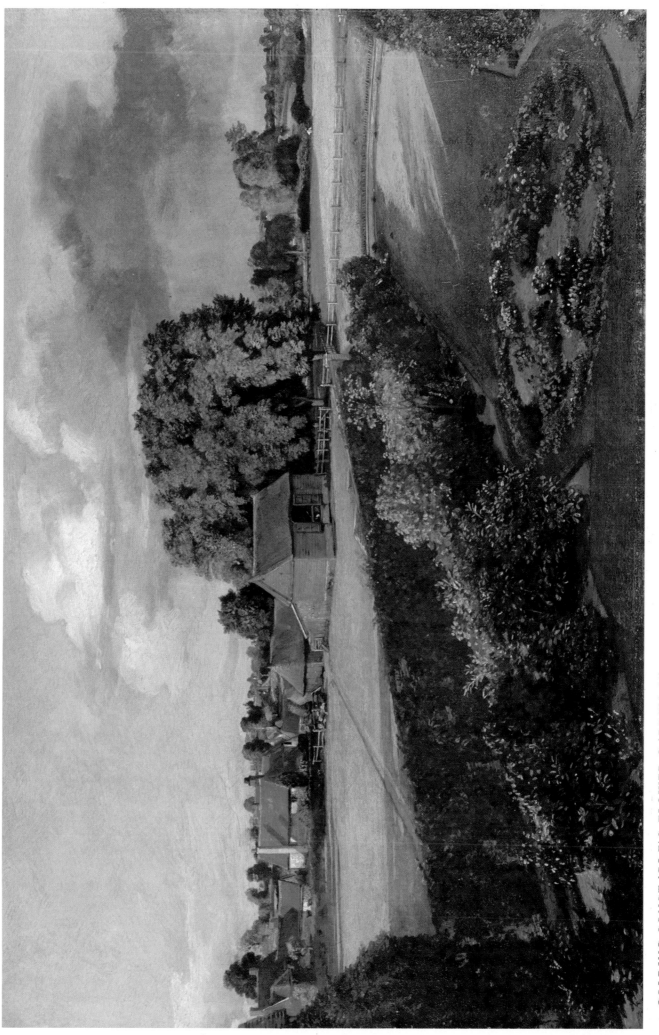

11. *GOLDING CONSTABLE'S FLOWER GARDEN*. Oils on canvas : 13 × 20 ins. About 1810.
Ipswich Museum (Christchurch Mansion) *(Reproduced by permission of the Ipswich Museums Committee)*

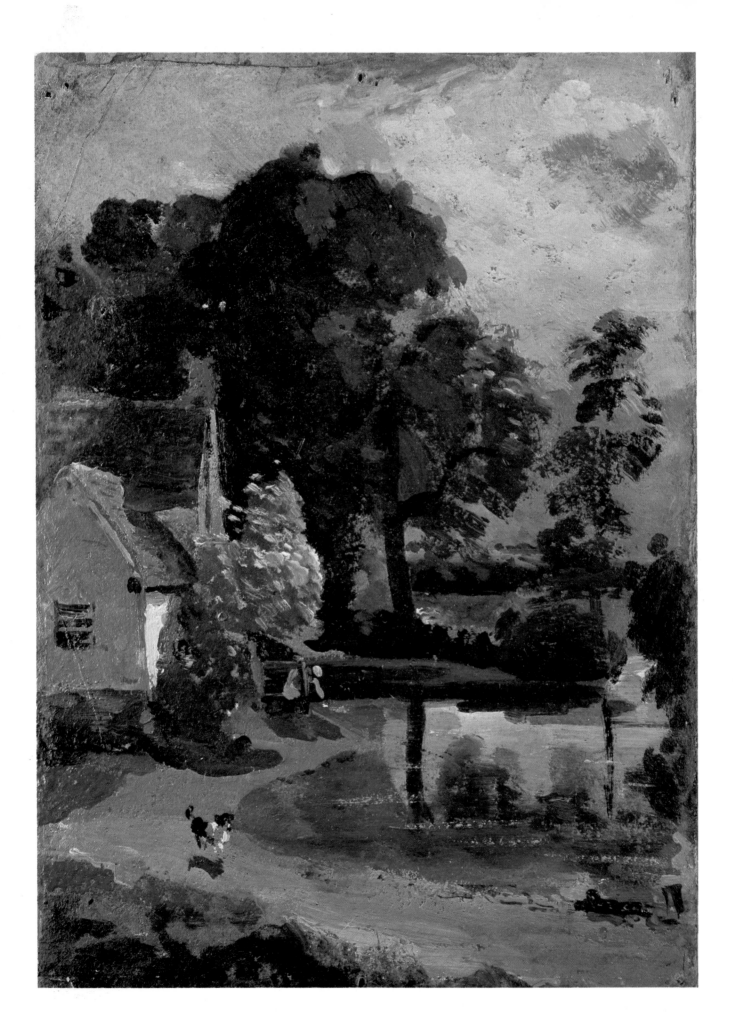

12. *WILLY LOT'S HOUSE.* Oils on paper : $9\frac{1}{2} \times 7\frac{1}{8}$ ins. About 1810–15? London, Victoria and Albert Museum

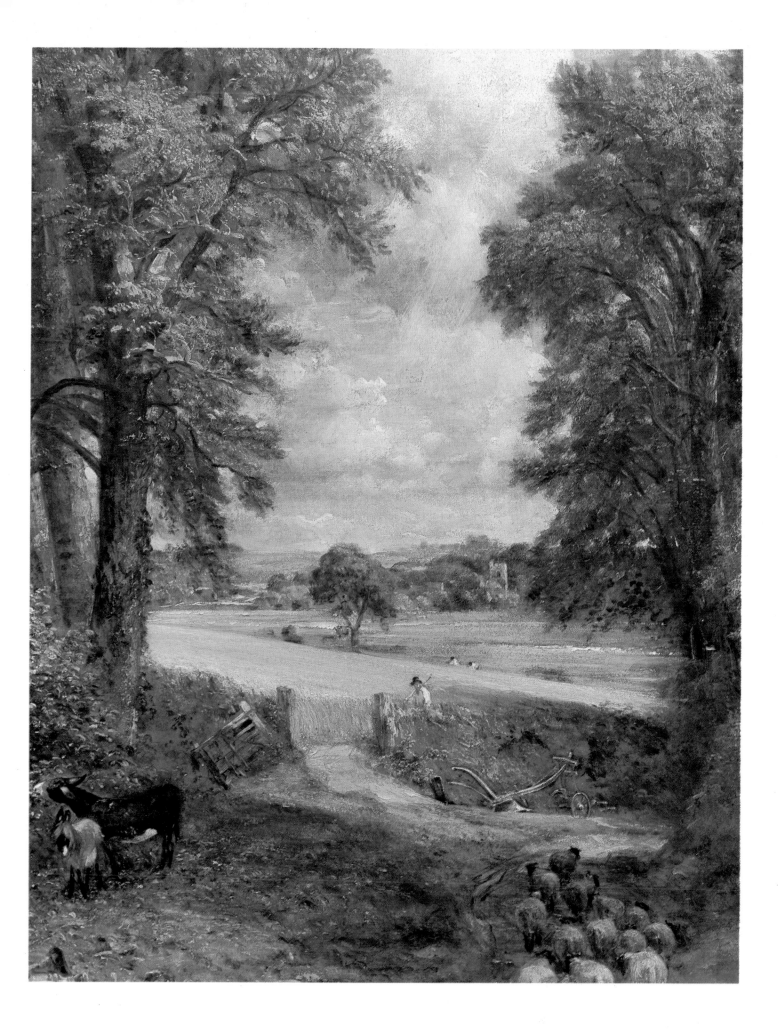

13. Detail from *THE CORNFIELD* (*Plate* 3)

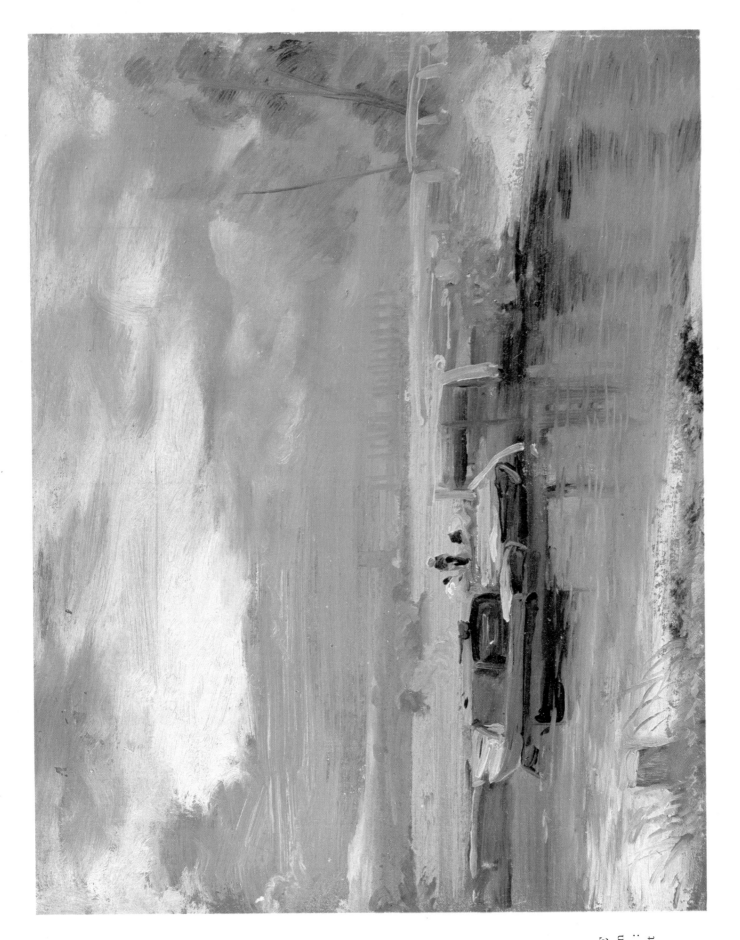

14. *BARGES ON THE STOUR, WITH DEDHAM CHURCH IN THE DISTANCE*. Oils on paper, laid on canvas : 10¼ × 12¼ ins. About 1811? London, Victoria and Albert Museum

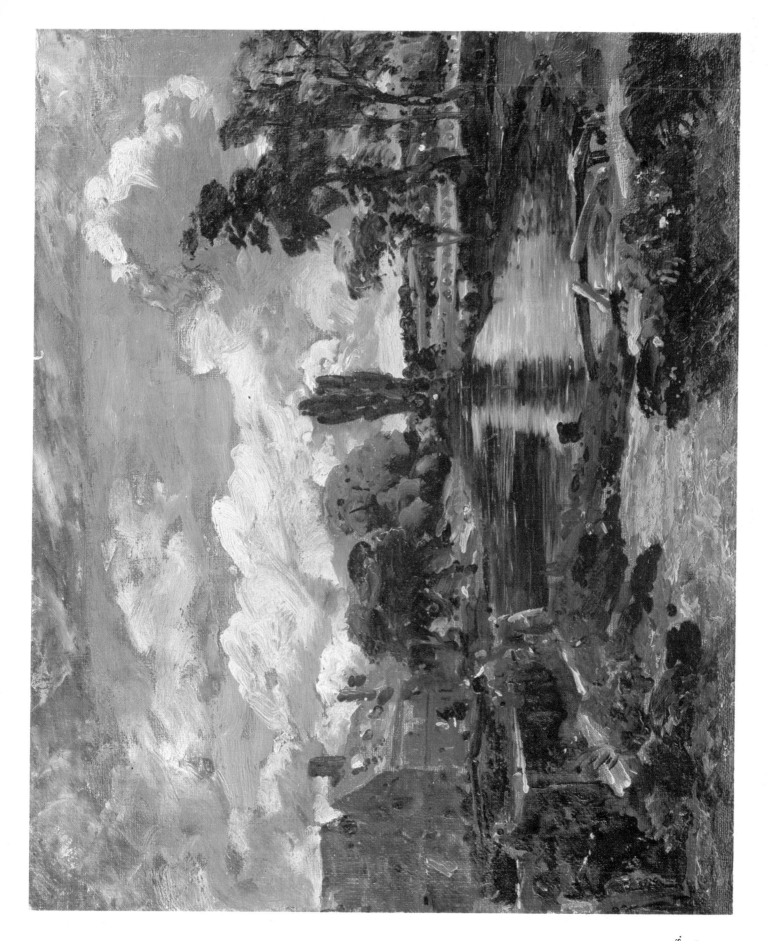

15. *FLATFORD
MILL FROM A
LOCK ON THE
STOUR*. Oils on
canvas : $9\frac{3}{4} \times 11\frac{3}{4}$ ins.
About 1811? London,
Victoria and Albert
Museum

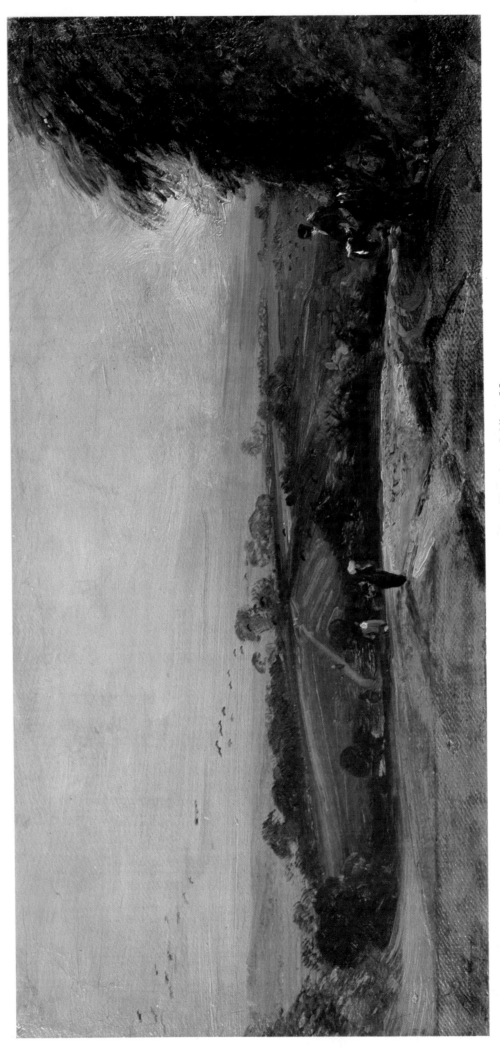

16. *AUTUMNAL SUNSET*. Oils on paper on canvas : $6\frac{3}{4} \times 13\frac{1}{4}$ ins. About 1812. London, Victoria and Albert Museum

17. *STUDY OF A HOUSE AMIDST TREES : EVENING*. Oils on paper : $9\frac{7}{8} \times 12\frac{1}{8}$ ins. October 4, 1823. London, Victoria and Albert Museum

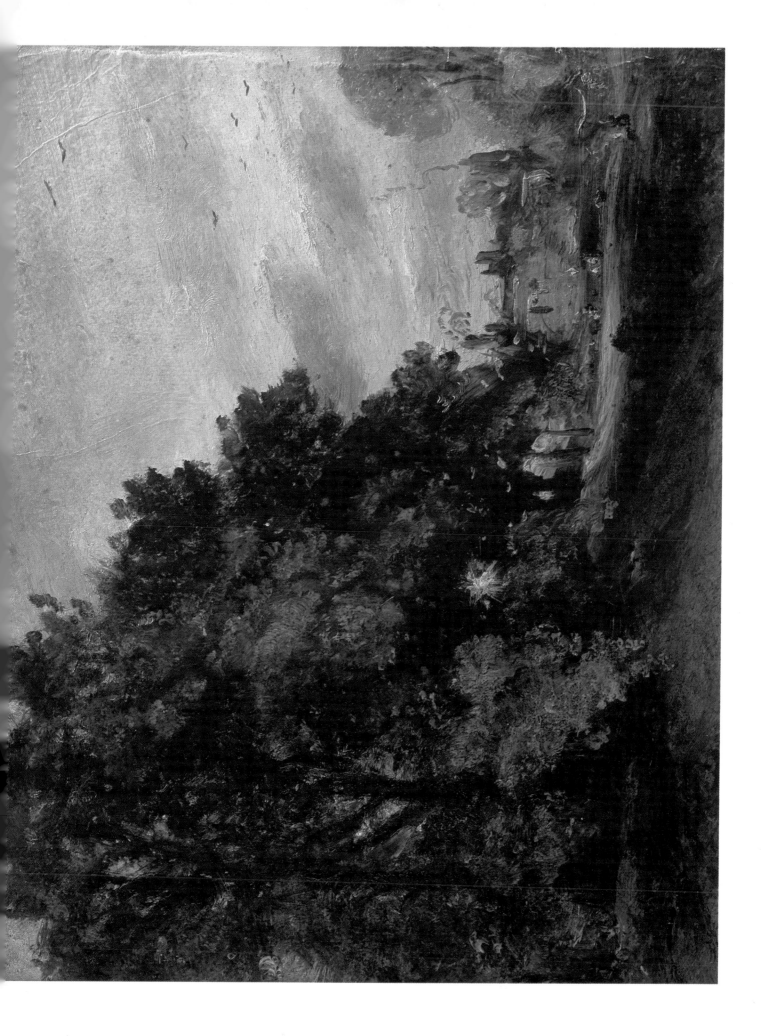

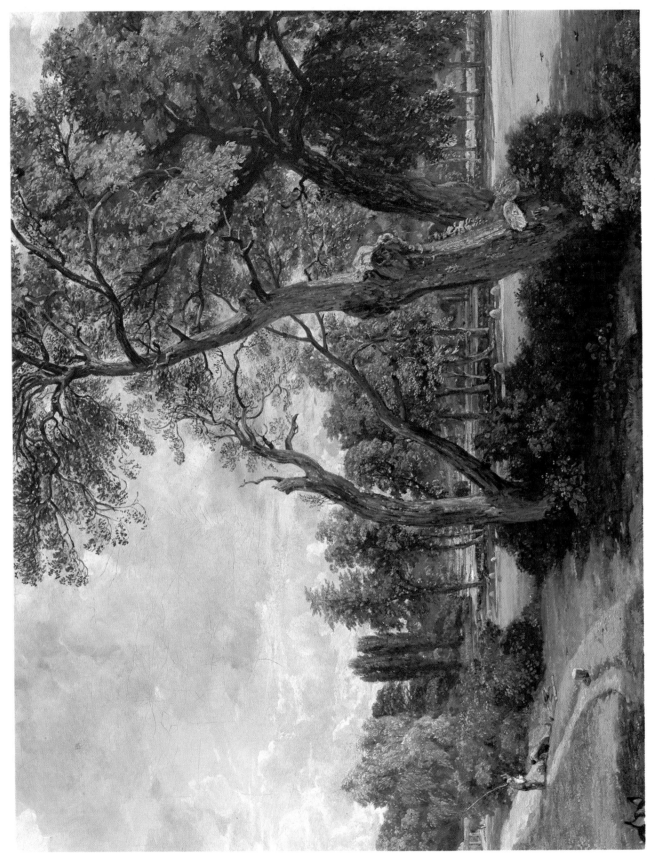

18. Detail from *FLATFORD MILL, ON THE RIVER STOUR* (Plate 20)

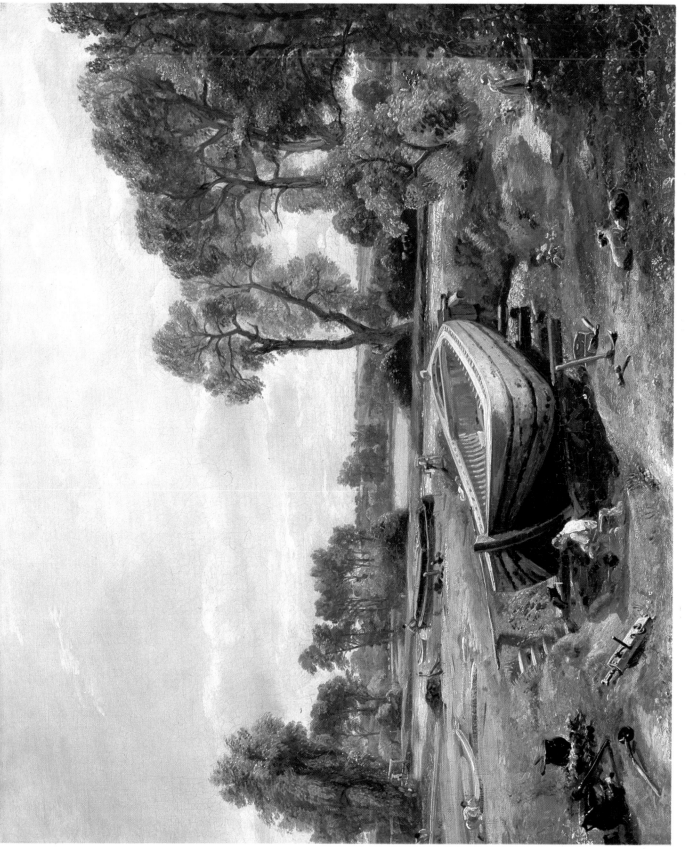

19. *BOAT-BUILDING NEAR FLATFORD MILL.* Oils on canvas : 20 × 24¼ ins. 1815. London, Victoria and Albert Museum

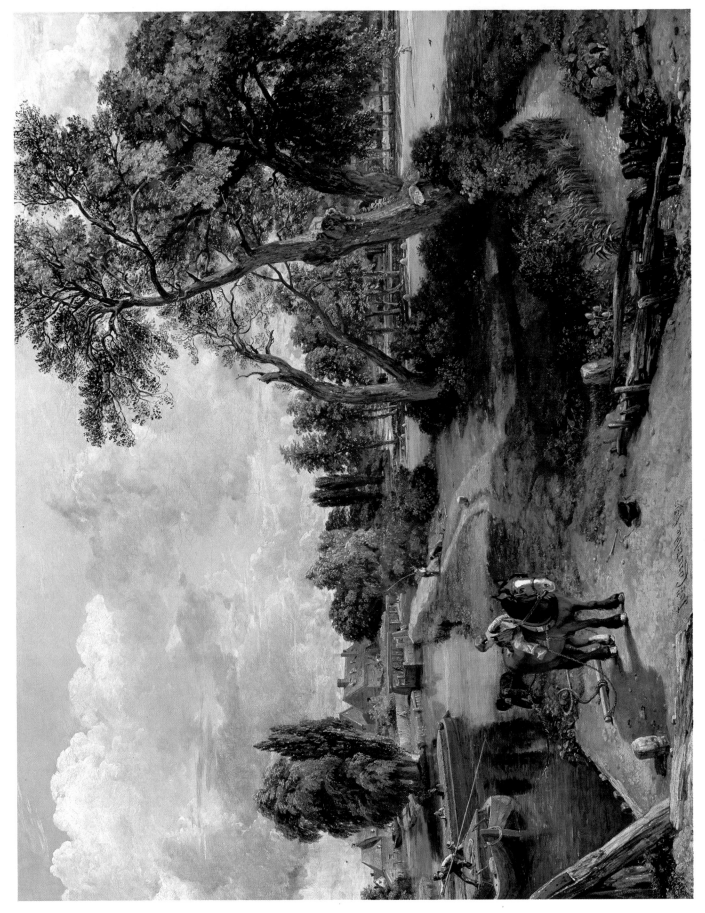

20. *FLATFORD MILL, ON THE RIVER STOUR.* Oils on canvas : 40 × 50 ins. 1817. London, Tate Gallery

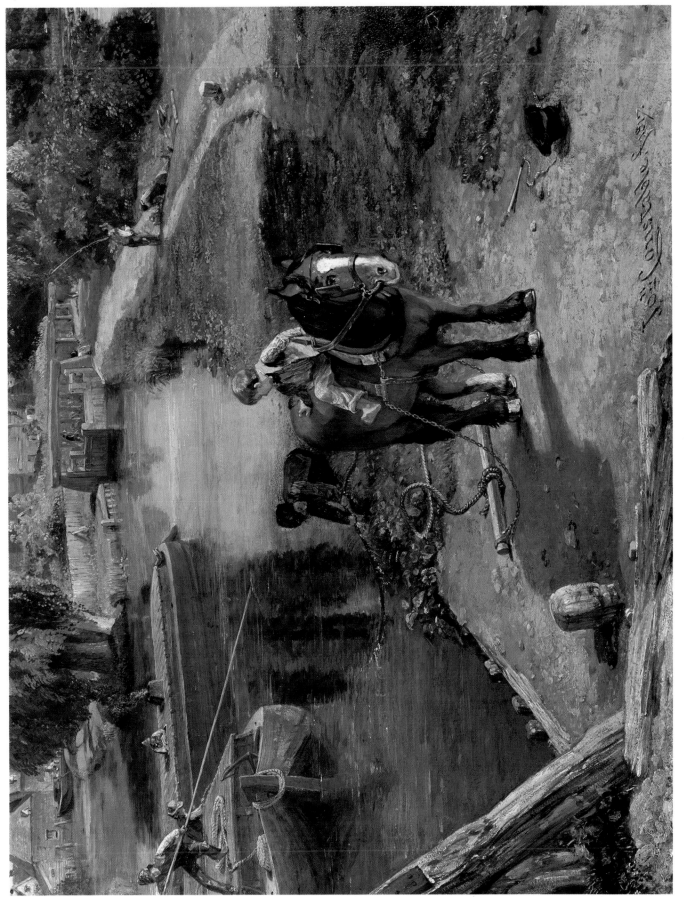

21. Detail from *FLATFORD MILL, ON THE RIVER STOUR (Plate 20)*

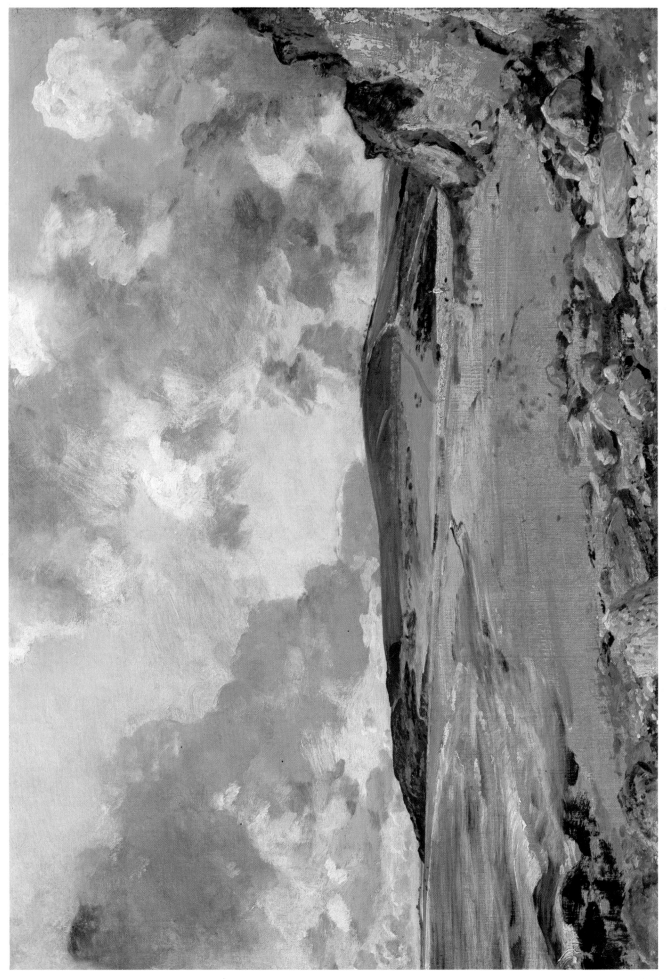

22. *WEYMOUTH BAY*. Oils on canvas : 20¾ × 29½ ins. 1816–17 or later. London, National Gallery

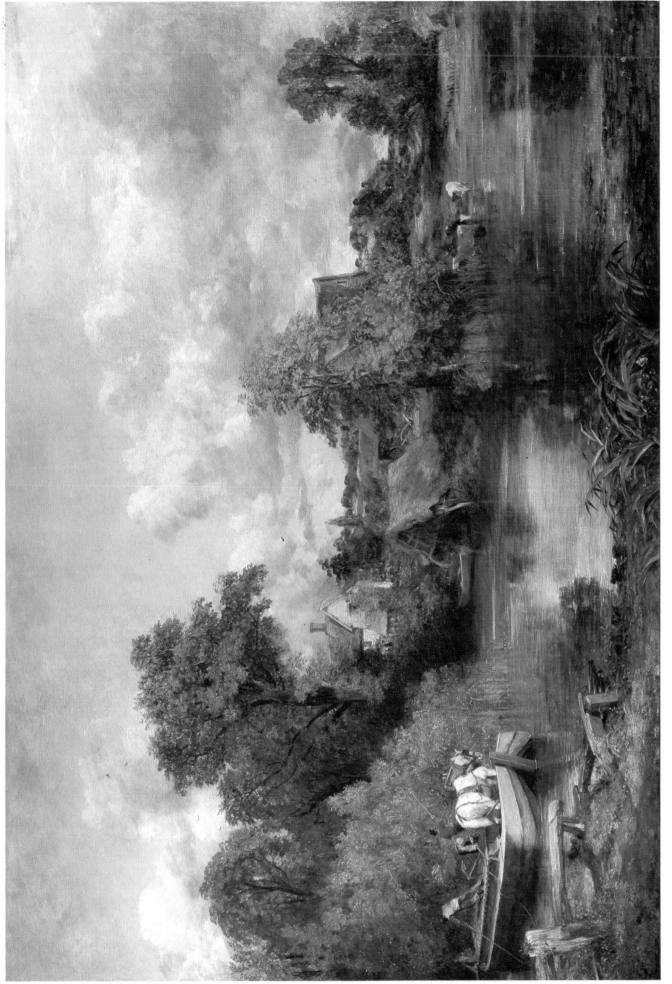

23. *THE WHITE HORSE*. Oils on canvas : $51\frac{3}{4} \times 74\frac{1}{8}$ ins. 1819. New York, Frick Collection (*Copyright The Frick Collection, New York*)

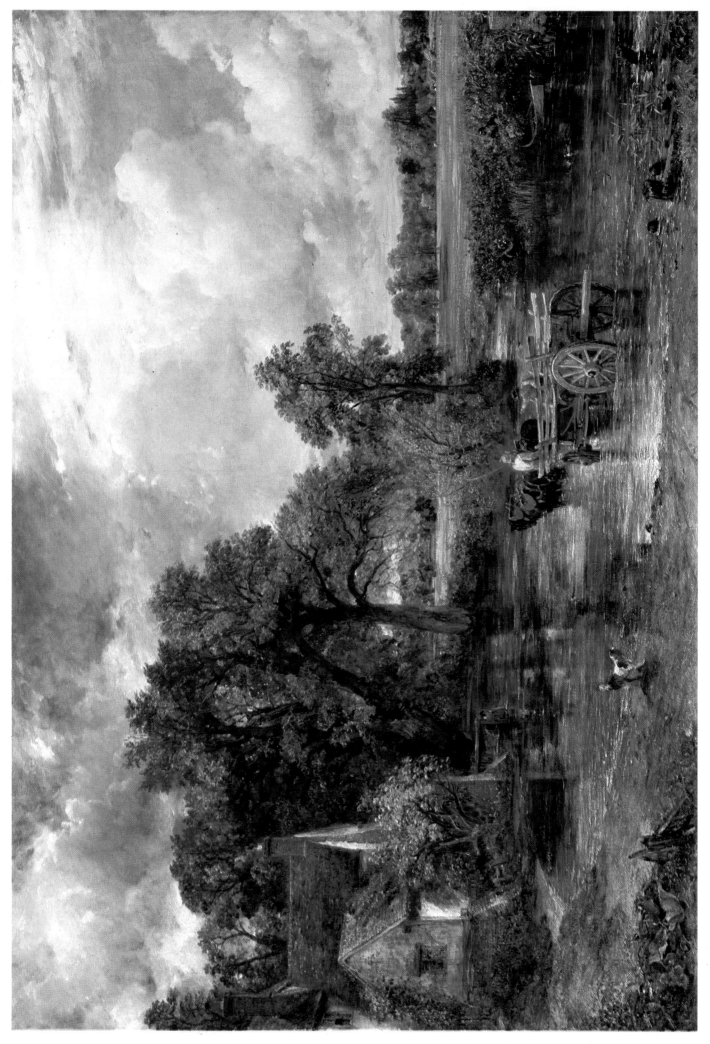

24. *THE HAYWAIN.* Oils on canvas : $51\frac{1}{2} \times 73$ ins. 1821. London, National Gallery

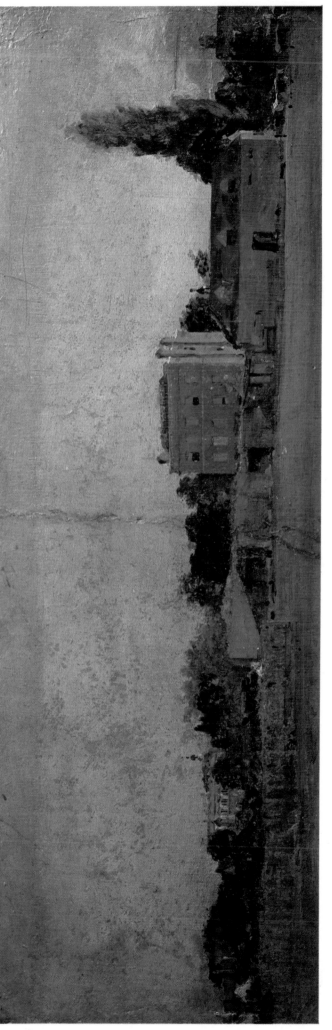

25. *GOLDING CONSTABLE'S HOUSE, EAST BERGHOLT*. Oils on millboard laid on panel : $7\frac{1}{8} \times 19\frac{7}{8}$ ins. About 1811. London, Victoria and Albert Museum

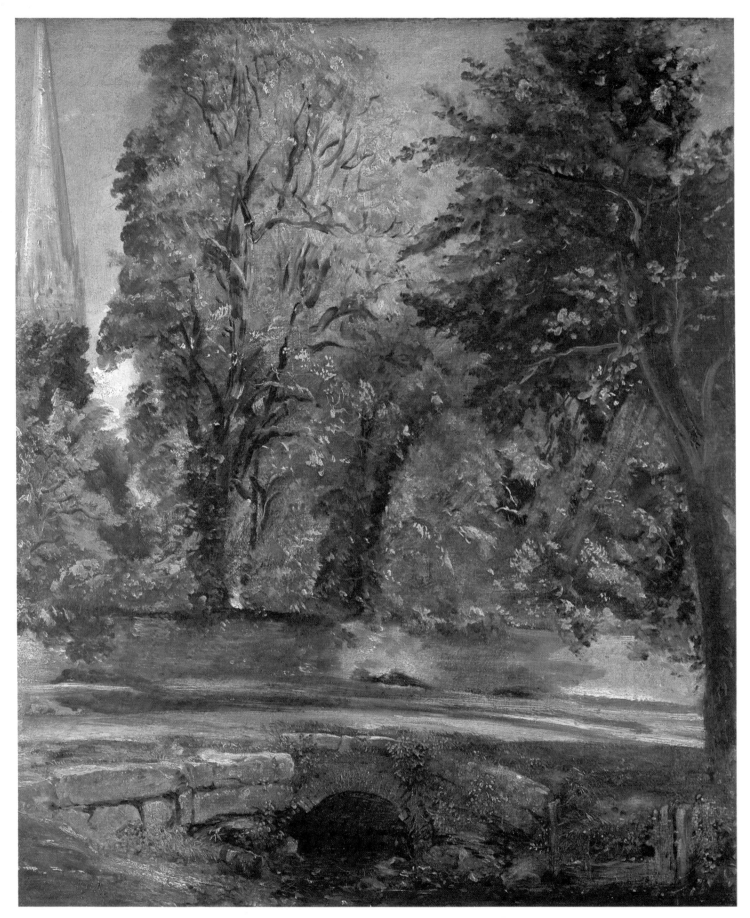

26. *SALISBURY : THE CLOSE WALL.* Oils on canvas : $23\frac{3}{4} \times 20\frac{1}{4}$ ins. 1821?
Cambridge, Fitzwilliam Museum (*Reproduced by permission of the Syndics of the Fitzwilliam Museum*)

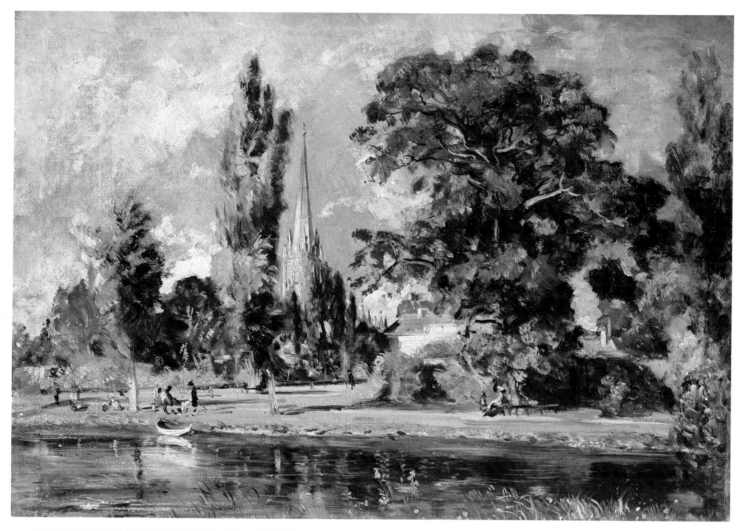

27. *SALISBURY CATHEDRAL FROM THE RIVER.* Oils on canvas : 20¾ × 30¼ ins. 1820's. London, National Gallery

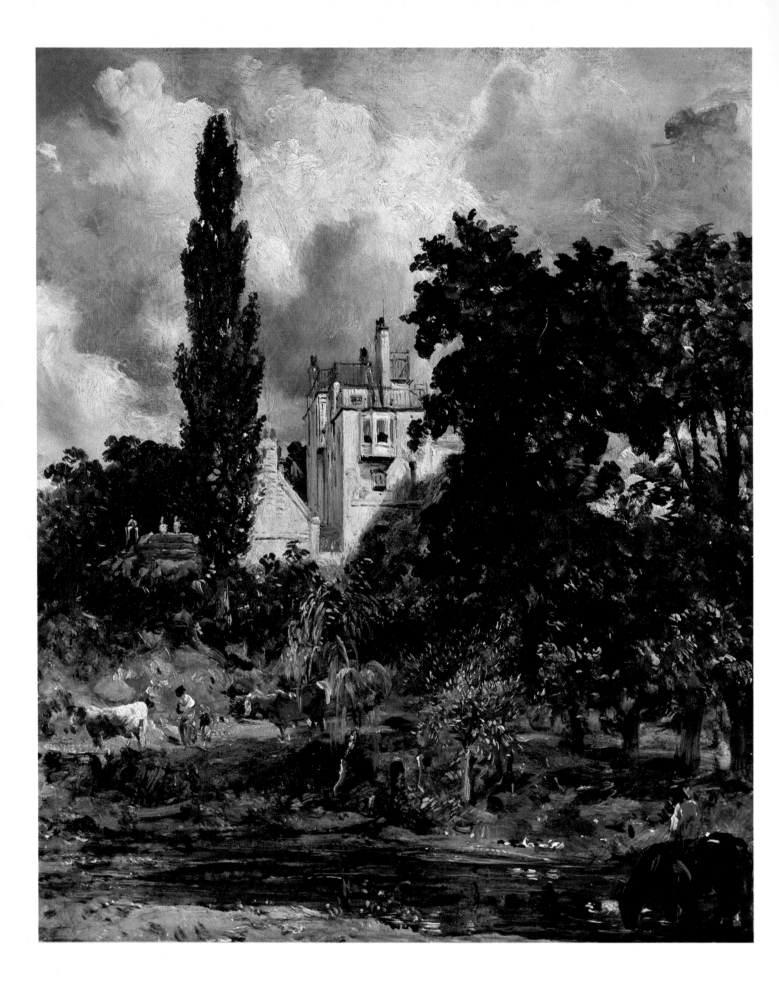

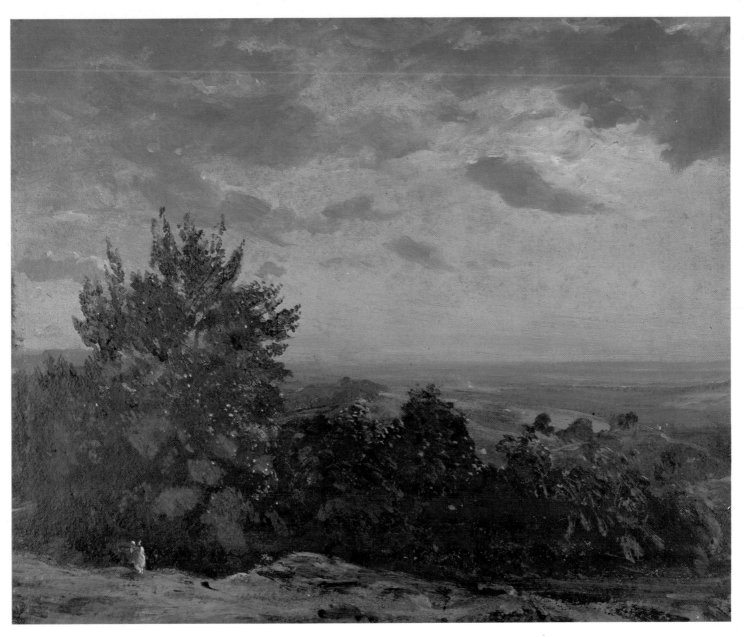

29. *LANDSCAPE STUDY : HAMPSTEAD LOOKING WEST*. Oils on paper on canvas : 10 × 11¾ ins.
 July 14, 1821. London, Royal Academy

28. *THE GROVE, HAMPSTEAD (THE ADMIRAL'S HOUSE)*. Oils on canvas : 14 × 11¾ ins.
 c. 1832. London, Tate Gallery

*3o. BUILDINGS ON
RISING GROUND
NEAR HAMPSTEAD.*
Oils on paper: $9\frac{3}{4} \times 11\frac{3}{4}$ ins.
October 13, 1821. London,
Victoria and Albert
Museum

31. *BRANCH HILL POND, HAMPSTEAD.* Oils on canvas : $9\frac{5}{8} \times 15\frac{1}{2}$ ins. About 1821–22. London, Victoria and Albert Museum

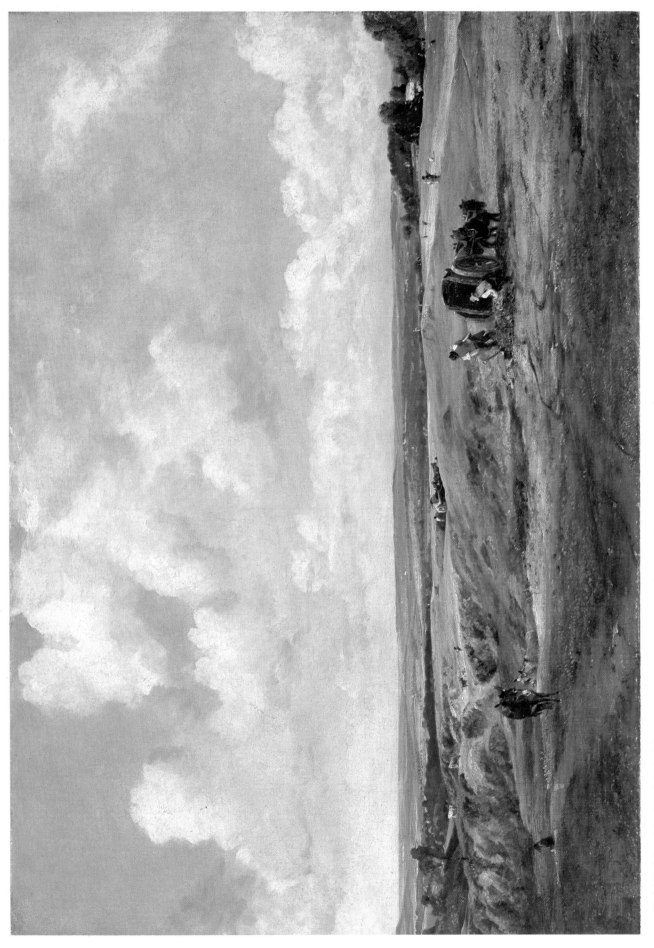

32. *HAMPSTEAD HEATH.* Oils on canvas : 21 × 30 ins. About 1818.
Cambridge, Fitzwilliam Museum *(Reproduced by permission of the Syndics of the Fitzwilliam Museum)*

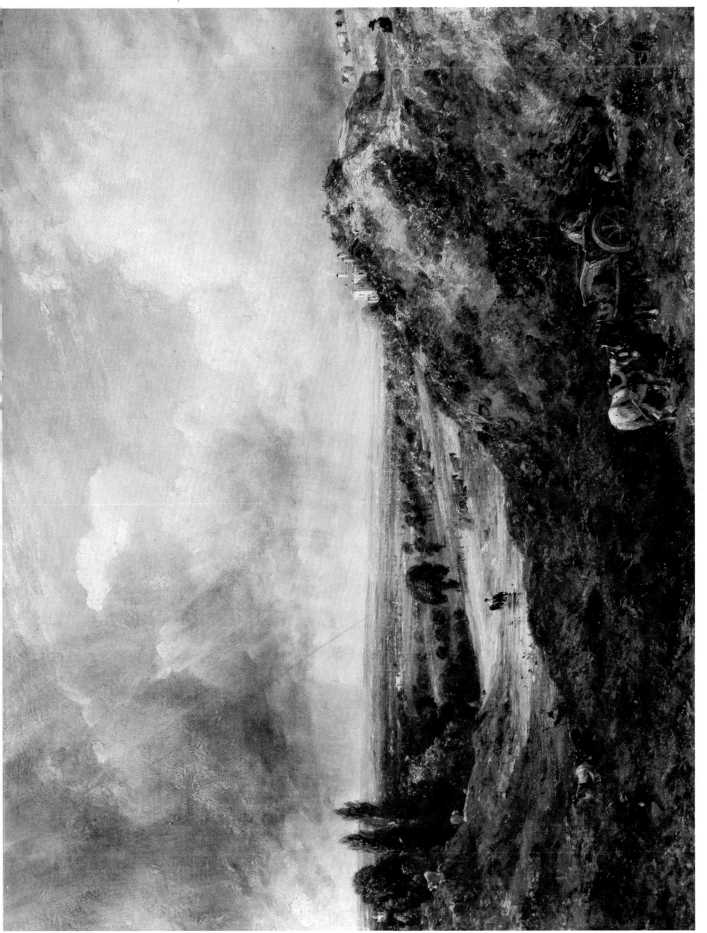

33. *HAMPSTEAD HEATH: BRANCH HILL POND*. Oils on canvas : $23\frac{1}{2} \times 30\frac{1}{2}$ ins. 1828. London, Victoria and Albert Museum

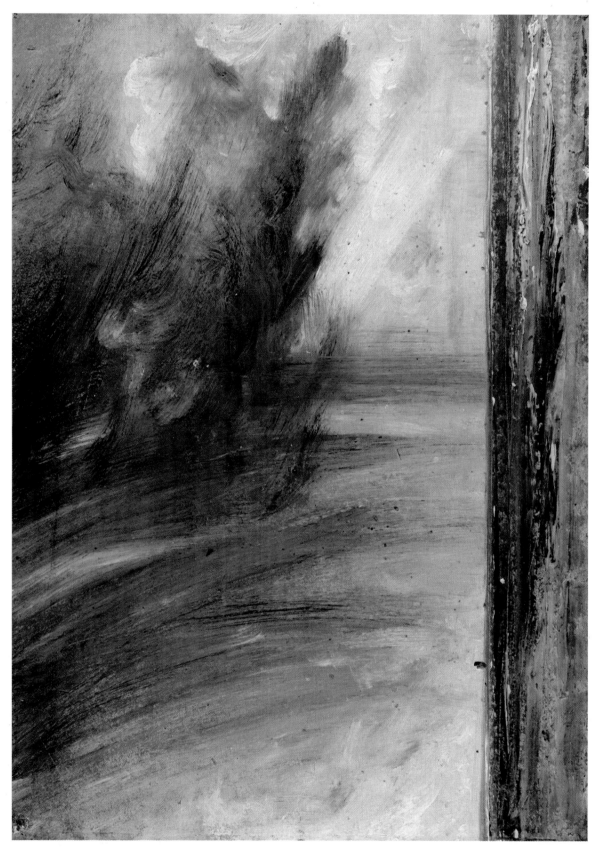

34. *SEASCAPE STUDY WITH RAIN CLOUDS (NEAR BRIGHTON?)*. Oils on paper on canvas : $8\frac{3}{4} \times 12\frac{1}{4}$ ins. About 1824–25.
London, Royal Academy

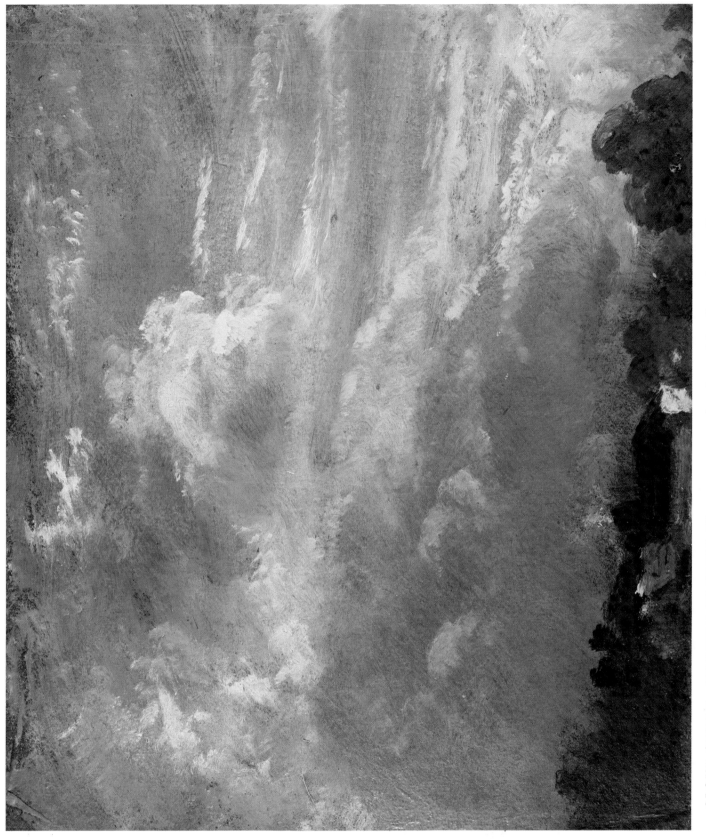

35. *CLOUD STUDY : HORIZON OF TREES.* Oils on paper on panel : $9\frac{3}{4} \times 11\frac{1}{2}$ ins. September 27, 1821.
London, Royal Academy

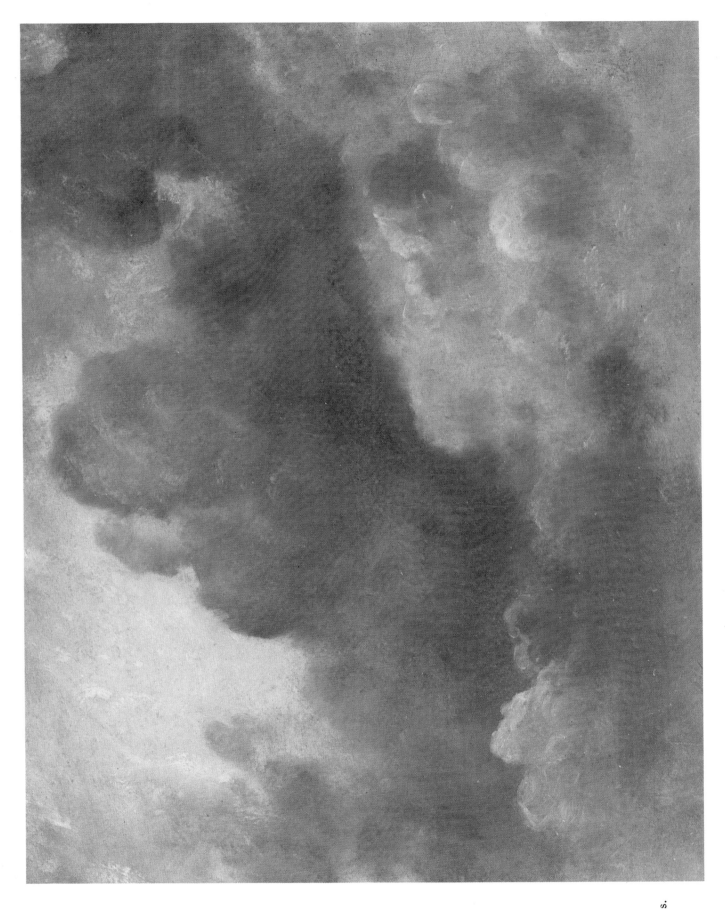

36. *STUDY OF CLOUDS*. Oils on canvas : $18\frac{3}{4} \times 22\frac{1}{2}$ ins. About 1822. London, Tate Gallery

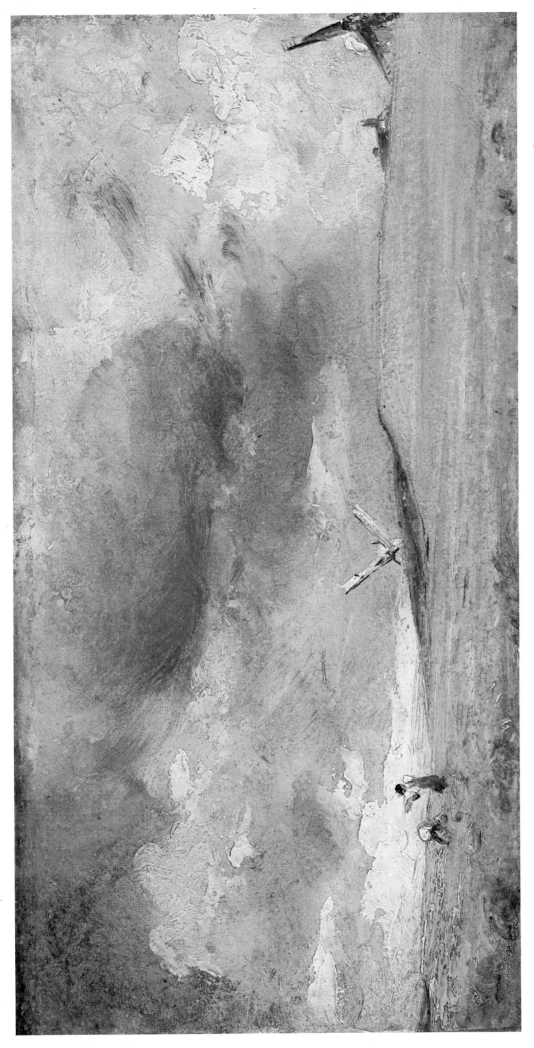

37. *THE GLEANERS, BRIGHTON*. Oils on canvas : 6¼ × 12 ins. 1824. London, Tate Gallery

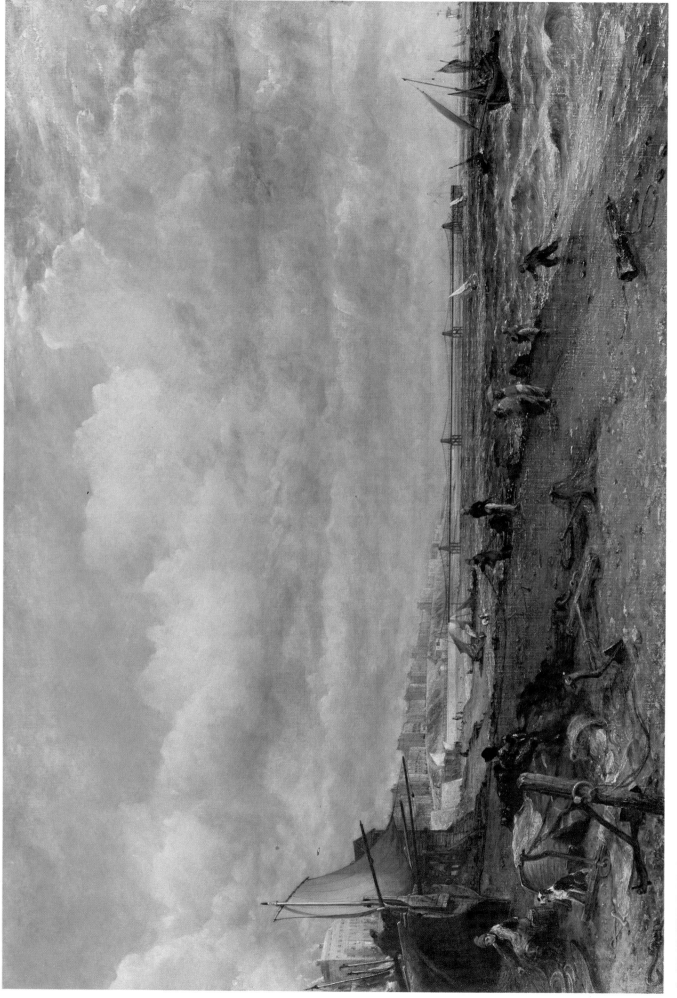

38. *MARINE PARADE AND CHAIN PIER, BRIGHTON*. Oils on canvas : 50 × 72¾ ins. 1824–27. London, Tate Gallery

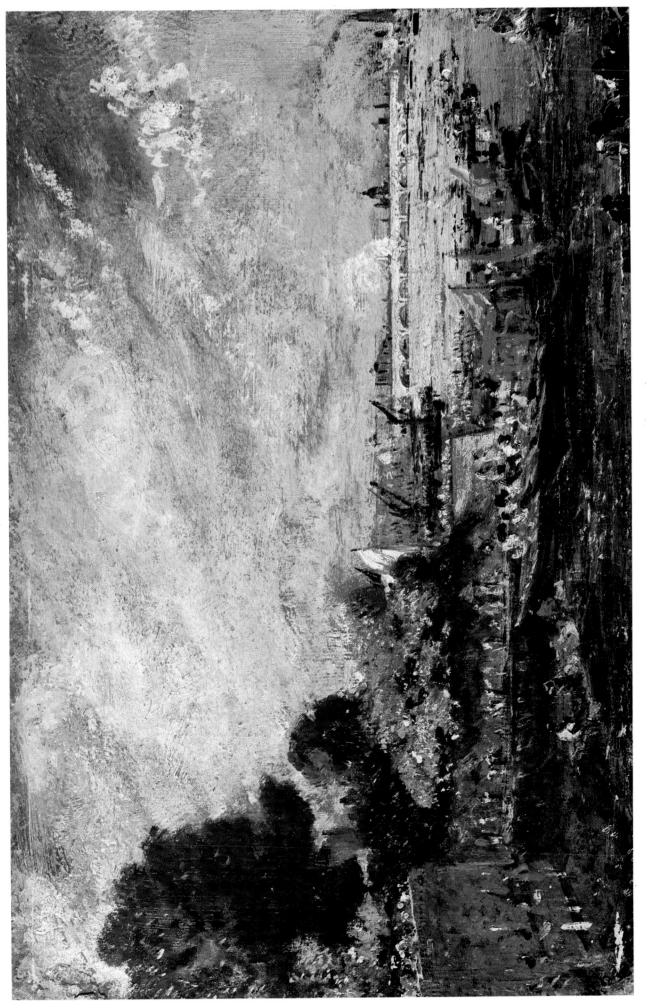

39. *WATERLOO BRIDGE FROM WHITEHALL STAIRS.* Oils on millboard : 11½ × 19 ins. About 1819?
London, Victoria and Albert Museum

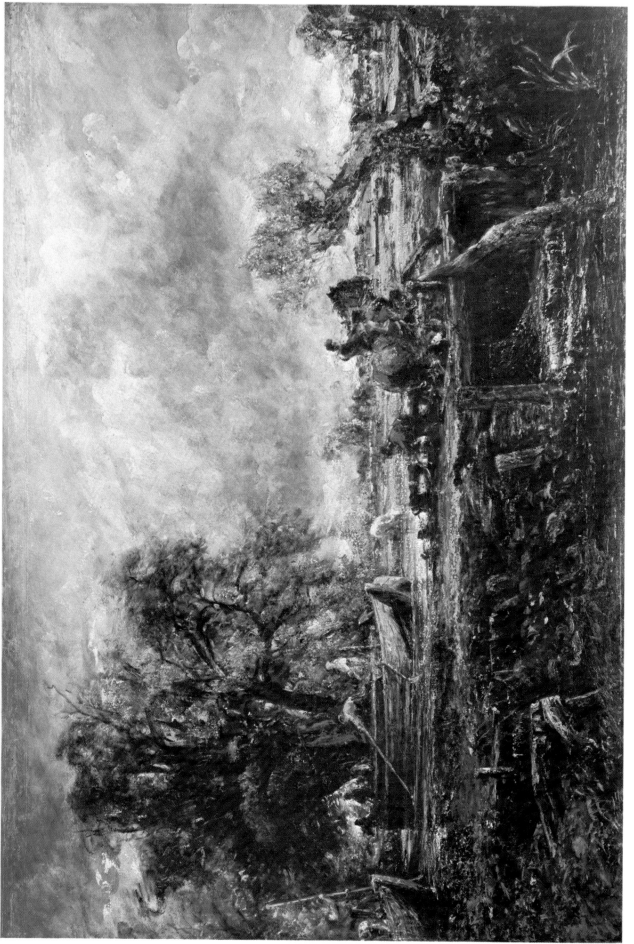

40. *FULL-SCALE STUDY FOR 'THE LEAPING HORSE'*. Oils on canvas : 51 × 74 ins. About 1825. London, Victoria and Albert Museum

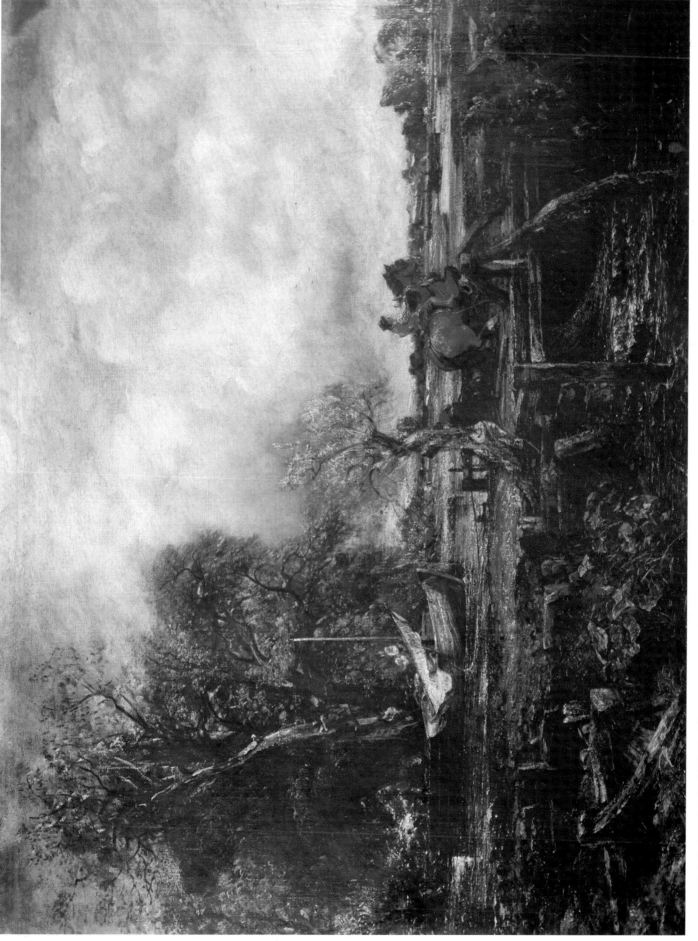

41. 'THE LEAPING HORSE'. Oils on canvas : $53\frac{1}{2} \times 71$ ins. 1825. London, Royal Academy

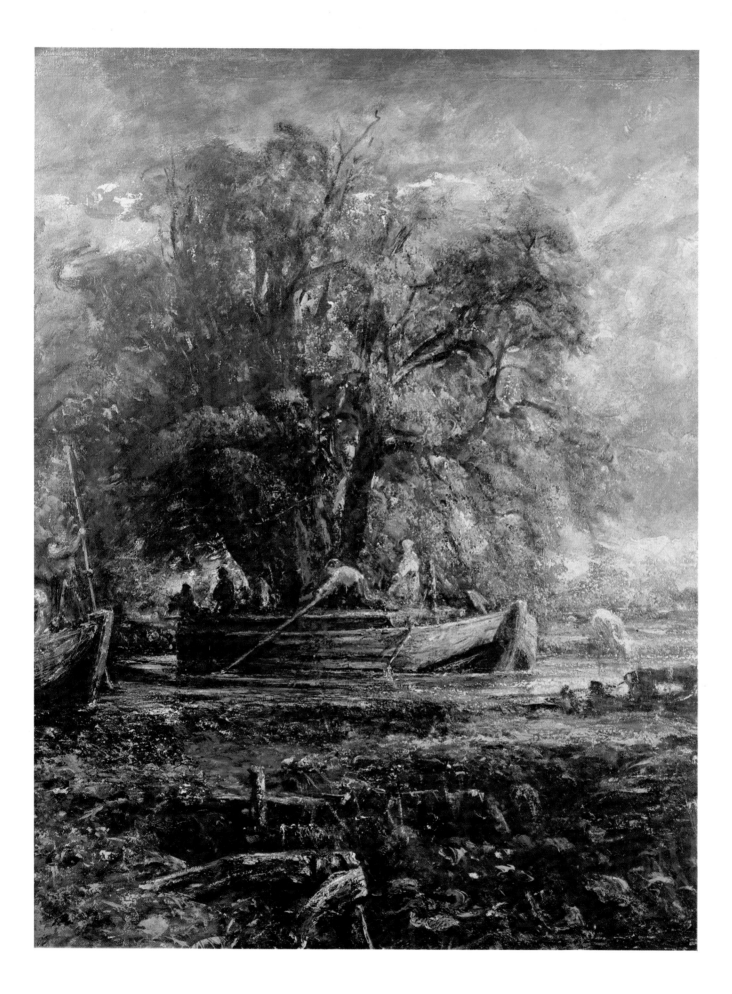

42. Detail from *STUDY FOR 'THE LEAPING HORSE'* (*Plate* 40)

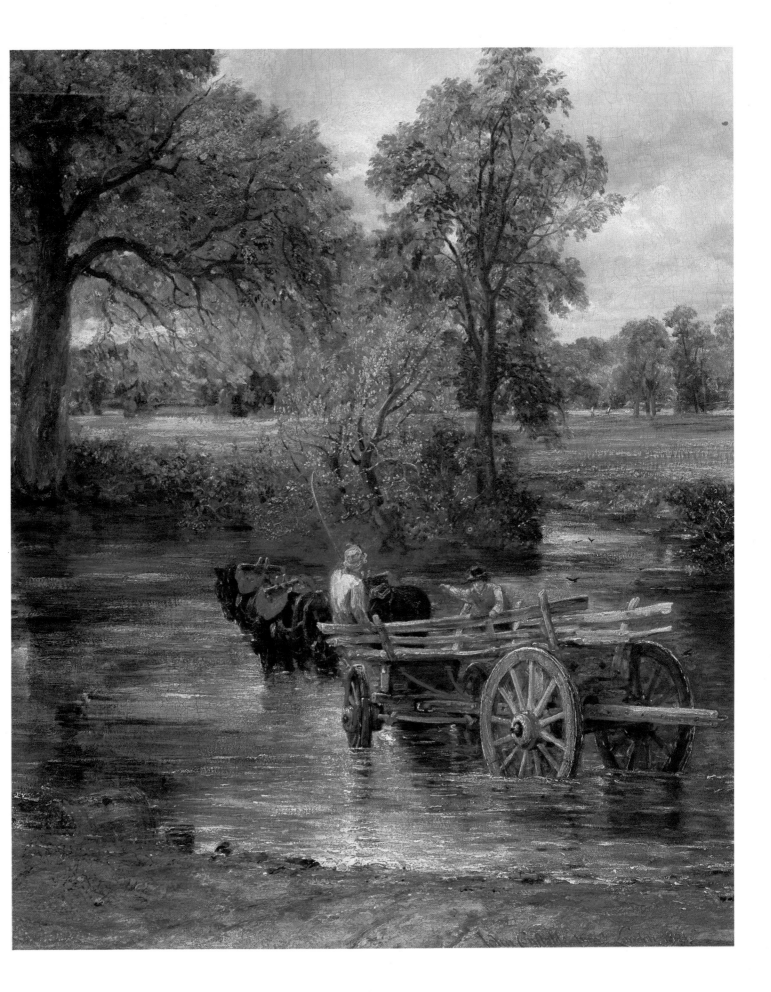

43. Detail from *THE HAYWAIN* (*Plate* 24)

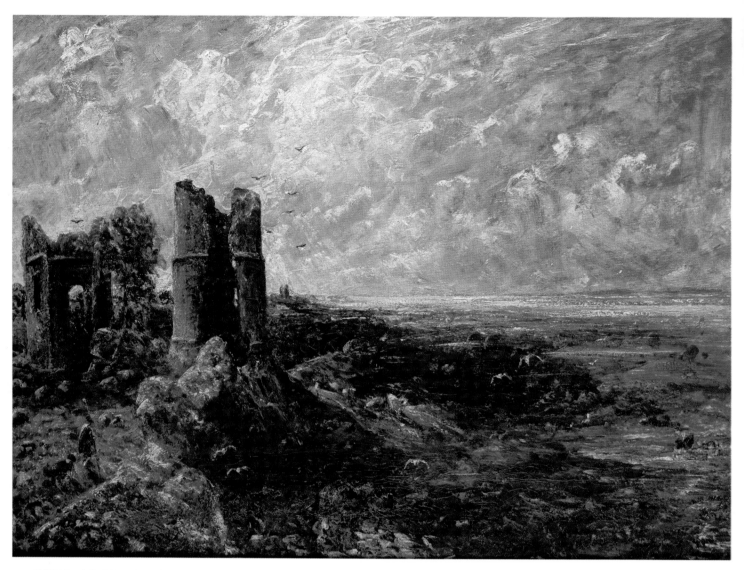

44. *FULL-SCALE STUDY FOR 'HADLEIGH CASTLE'*. Oils on canvas : 48½ × 65¾ ins. About 1829. London, Tate Gallery

45. *THE VALLEY FARM*. Oils on canvas : 58½ × 49½ ins. 1835. London, Tate Gallery

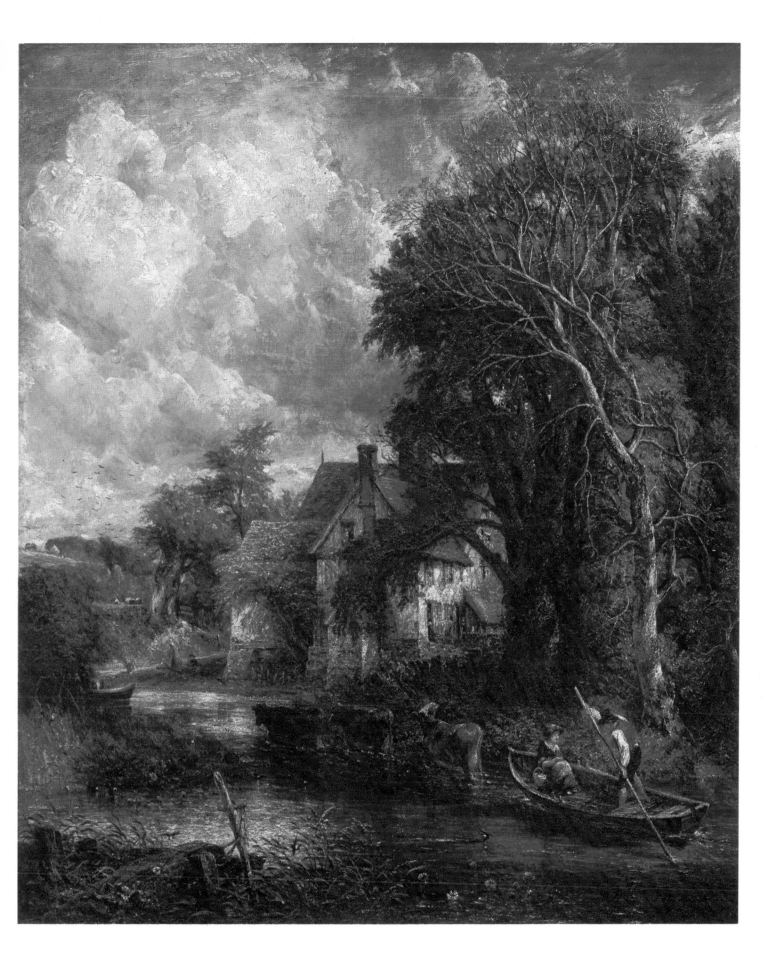

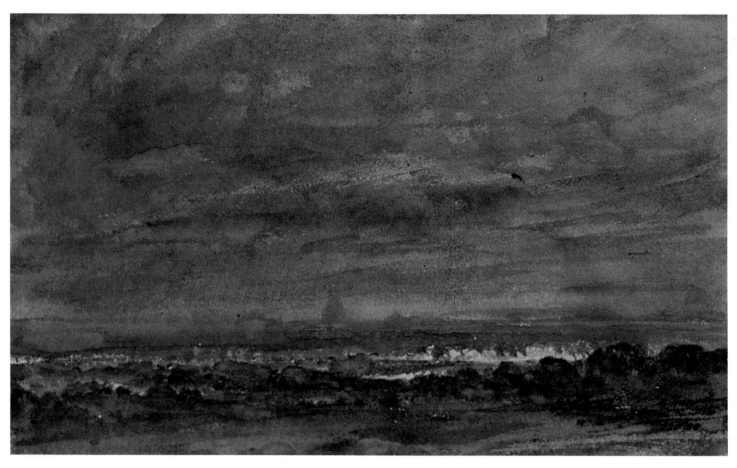

46. *VIEW AT HAMPSTEAD, LOOKING TOWARDS LONDON.* Watercolour : $4\frac{1}{2} \times 7\frac{1}{2}$ ins.
 December 7, 1833. London, Victoria and Albert Museum

47. *TREES AND A STRETCH OF WATER ON THE STOUR* (?). Pencil and sepia wash : $8 \times 6\frac{3}{8}$ ins. About 1830–36.
 London, Victoria and Albert Museum

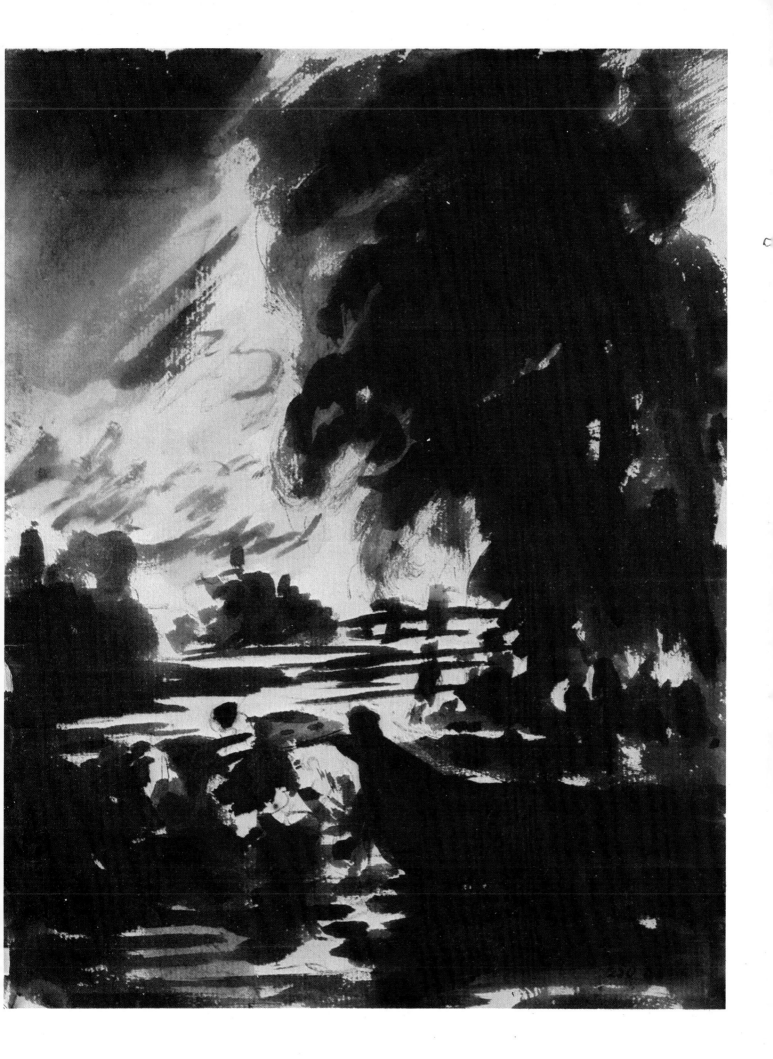

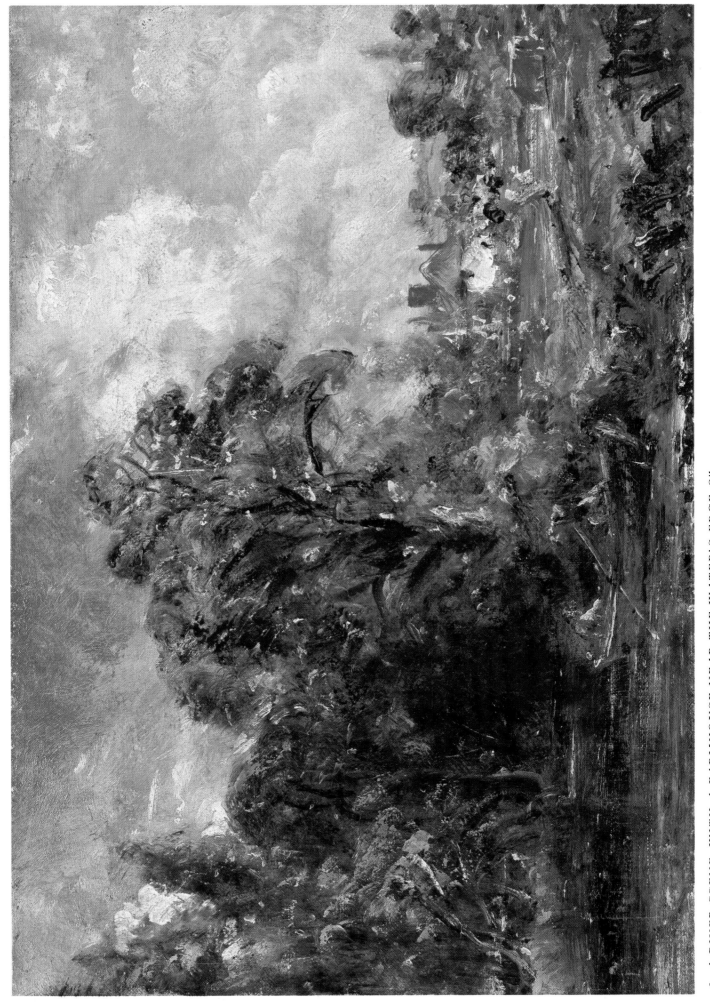

48. *A RIVER SCENE, WITH A FARMHOUSE NEAR THE WATER'S EDGE.* Oils on canvas :
10 × 13¾ ins. About 1830–36. London, Victoria and Albert Museum